**Central
Point**

DATE DUE	9 01		
30 '01			
NOV 21 '01			
JAN 05 '02			
APR 08 '03			
4-29-03			
GAYLORD			PRINTED IN U.S.A.

12/03

Angel

Collectibles

Debra S. Braun

Schiffer Publishing Ltd

880 Lower Valley Road, Atglen, PA 19310 USA

Dedication

This book is dedicated to everyone who believes that "every time a bell rings an angel gets his wings" – *It's a Wonderful Life* ©Frances Goodrich, Albert Hackett, Frank Capra & Jo Swerling.

Disclaimer

All pictures, graphics, and photos compiled herein are intended to heighten the awareness of angels and related products. This book is in no way intended to infringe on the intellectual property rights of any party. All products, brands, and names represented are trademarks or registered trademarks of their respective companies. The information in this book was derived from the author's independent research and was not authorized, furnished or approved by the companies represented.

Copyright © 2001 by Debra S. Braun
Library of Congress Card Number: 00-112050

Designed by Bonnie M. Hensley
Cover design by Bruce M. Waters
Type set in Korinna BT

ISBN: 0-7643-1342-8
Printed in China
1 2 3 4

Published by Schiffer Publishing Ltd.
4880 Lower Valley Road
Atglen, PA 19310
Phone: (610) 593-1777; Fax: (610) 593-2002
E-mail: Schifferbk@aol.com
Please visit our web site catalog at **www.schifferbooks.com**

In Europe, Schiffer books are distributed by Bushwood **Books**
6 Marksbury Avenue Kew Gardens
Surrey TW9 4JF England
Phone: 44 (0) 20-8392-8585; Fax: 44 (0) 20-8392-9876
E-mail: Bushwd@aol.com
Free postage in the UK. Europe: air mail at cost.

This book may be purchased from the publisher.
Include $3.95 for shipping. Please try your bookstore first.
We are always looking for people to write books on new and related subjects.
If you have an idea for a book please contact us at the above address.
You may write for a free catalog.

Contents

Acknowledgments

I would like to extend a special thanks to my parents, Mark Coté, Peter and Nancy Schiffer, Douglas Congdon-Martin, editor, Bruce Waters, Tracey Curry, Paul Austin, and the staff at Wink One Hour Photo. All of these people were instrumental in the development of this book. I really appreciate all of their guidance and support.

I would also like to thank my co-workers and friends [especially my bowling buddies–Kendra Giza, Mari McGowan , Kathy Ritz, Donna Schroeder, and Sue Zak]. Thanks for believing in me and making me smile.

Photography by: TOBY

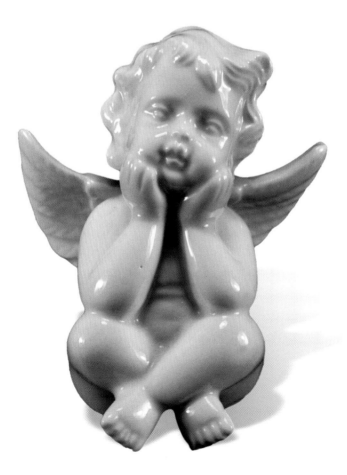

Introduction

Do you believe in celestial beings? Have you sensed their presence? According to the bible, God commands an infinitive number of angels. Psalm 91:10-11 (RSV) records, "He will give His angels charge of you, to guard you in all your ways. On their hands they will bear you up, lest you dash you foot against a stone." Perhaps these angelic hosts account for events that are deemed unexplainable.

• Captain Eddie Rickenbacker and his crew were shot down during World War II. For several weeks the media followed their disappearance over the Pacific Ocean with no leads. Mayor LaGuardia encouraged New York City residents to pray for their survival and a miracle happened. They returned home. Newspapers quoted Rickenbacker as saying, "And this part I would hesitate to tell. Except that there were six witnesses who saw it with me. A [sea]gull came out of nowhere, and lighted [fell unexpectedly] on my head – I reached up my hand very gently – I killed him and then we divided him equally among us. We ate every bit, even the little bones. Nothing ever tasted so good." *Did an angel bring the [sea]gull to help them survive?*

• Harry Houdini [Ehrich Weiss] was a master of illusion. He lived from 1874-1926. Over the years, his stunts became progressively more difficult and dangerous. His acts ranged from making a 10,000-pound elephant disappear to escaping straitjackets and underwater cells. Houdini enjoyed shocking and marveling audiences. After performing an underwater escape, he would often stage his own death by hiding under a nearby dock. He was agile and in excellent physical condition. In 1953, his life was immortalized in a big screen biography called *Houdini*. According to the Paramount movie, one of his underwater stunts went awry. When he lost his way under the thick ice, he was guided to safety by his departed mother's voice. *Could the voice that Houdini heard have been from an angel?*

• In 1865, Abraham Lincoln shared an unsettling dream about his own death. His close friend, Ward Hill Lamon documented it as follows: "Before me [President Lincoln] was a catafalque, on which rested a corpse wrapped in funeral vestments. Around it were stationed soldiers who were acting as guards; and there was a throng of people, some gazing mournfully upon the corpse, whose face was covered, others weeping pitifully. 'Who is dead in the White House?' I demanded of one of the soldiers. ' The President,' was his answer. 'He was killed by an assassin.'" It's ironic, President Lincoln was shot in the back of the head at Ford's theater on the evening of April 14, 1865. He died at 7:22 AM the next morning. *Were the "stationed soldiers" actually celestial armies?*

Overview

The summary below will help you become familiar with several types of angels that can be found on collectible merchandise. If you are interested in learning even more about Angelology, the following resources are excellent: *Angels A-Z* by James R. Lewis and Evelyn Dorothy Oliver and *A Book of Angels* by Sophy Burnham.

Biblical Angels

Angel: The word *angel* is a derivative of the Greek word, *angelos*. It means "messenger." Angels are spiritual entities that can channel God's messages to us through voices (verbal or intuitive), dreams, and visions. They can become visible, but are primarily unseen. According to Christian lore, two [guardian] angels are assigned to each person at birth. One angel will sway him towards good, the other towards evil. It has been suggested that angel wings represent spirit, power, and speed. Artists often portray angels with luminous accents and multicolored wings. The color red symbolizes love whereas blue represents knowledge.

The appearance of an angel is described in Matthew 28:2-3, "And behold, there was a great earthquake: for the angel of the Lord descended from heaven, and came and rolled back the stone from the door, and sat upon it.

His countenance was like lightning, and his raiment white as snow."

Archangels: The word *arch* combined with *angel* roughly translates to an angel placed in a first or highest rank. Not only do Archangels carry God's messages, they also command His celestial armies. The scripture (Jude 9) states that there is only one archangel, Michael. However, it has been debated that other biblical references imply more. According to the Catholic Church, Archangels Gabriel, Michael, and Raphael guard the throne of God.

The name **Gabriel** means "strength to God." He is often portrayed with the color gold; perhaps to symbolize the divine messages he carried. Many artist renderings depict Gabriel dressed in majestic attire. He is often shown kneeling before Mary or carrying a scroll (scepter or lily). According to Matthew 1:12-21, Gabriel delivered the following message: "Joseph son of David, do not be afraid to take Mary home as your wife, because what is conceived in her is from the Holy Spirit. She will give birth to a son, and you are to give him the name Jesus, because he will save people from their sins." Catholics celebrate *The Feast of St. Gabriel* on March 24.

The name **Michael** means "looks like God." He is often portrayed with the color blue; perhaps to symbolize his duty to protect heaven and maintain harmony. Many artist renderings depict Michael dressed in armor. According to The Book of Enoch, Michael led God's celestial army in the *Battle of Heaven*. In triumph, they banished Lucifer and his followers to hell. Some people believe that Michael will be sent to conquer the Antichrist during the Apocalypse. Roman Catholics celebrate *Michaelmas* on September 29.

The name **Raphael** means "medicine of God." He is often portrayed with the color green; perhaps to symbolize his ability to heal. Many artist renderings depict Raphael with young Tobias. He is often shown carrying a staff, water gourd, and wallet (complete with shoulder strap). Raphael leads the guardian angels. According to The Book of Tobit, Raphael helped Tobias to restore his father's eyesight by using the liver from a fish. Even today, Raphael is called upon to heal the sick. Catholics celebrate *The Feast of St. Raphael* on May 18.

Cherubim: The word *cherubim* is based on the Hebrew noun *cherub*. It means "to be near." Cherubim are among the second highest rank and are led by Archangel Gabriel. Artists often portray cherubs as children with rosy cheeks and chubby bodies.

Seraphim: The word *seraphim* is based the Hebrew noun *saraph*. It means "to consume with fire." Seraphim are the angels of love, light, and fire. They are among the second highest rank and praise God with constant song. Artists often portray seraphim with six wings.

Angel-like

Cupid: The word *cupid* is based on Greek mythology. It means "desire." According to legend, Cupid (the Roman god of love) is affiliated with Eros and Aphrodite (the love goddess). He can best be described as a mischievous youth that can spark love into those he strikes. Artists often portray cupid as a winged boy who carries a bow and arrow.

Fairy: The word *fairy* is based on folklore. It means "goddess of fate." The most famous fairies were photographed in Cottingley, Yorkshire, England circa 1917-1920. Many people confuse fairies with angels. Two defining characteristics are that fairies are tiny beings [that live in the woods] and have butterfly [or insect] wings. In general, their wings are sectioned into four parts. I have placed one fairy in this book to show you the difference. Can you find it?

Kewpie: The word *Kewpie* is based on the word, *Cupid*. Illustrator Rose O'Neill (1874-1944) conceived the idea of a Kewpie from a dream. In 1909, the *Ladies Home Journal* introduced her chubby creation to the public. Original Kewpies are marked "O'Neill" and have tiny blue wings. If you are ever near Branson, Missouri, check out O'Neill's house. It has been converted to a Kewpie museum named "Bonnie Brook." For more information call: 1-800-539-7437.

Definition

The New Merriam-Webster Dictionary © 1989 defines an angel as "1: a spiritual being superior to man, 2: an attendant spirit (guardian), **3: a winged figure on human form in art,** 4: Messenger, Harbinger, 5: a person held to resemble an angel, 6: a "financial backer." The angel collectibles represented in this book will revolve around definition three.

Helpful Hints

Searching for angels at on-line auctions, flea markets, and garage sales is challenging and fun. You never know what you are going to find. It is important to understand that the prices for angel memorabilia will fluctuate according to their condition, supply, and demand. You should purchase an item because you like it, not for an investment. This book is intended to heighten your awareness of angel collectibles and their approximate values in excellent to mint condition on a secondary market. All of the items shown in this book were produced on or before 2000.

There are several things to consider before purchasing an object. For example: Is it in good condition? Are all of the pieces complete? Is it rare or hard to find?

• **Tip 1:** One way to identify a hairline crack in an object is to hold it up to a light. The hairline crack should stick out instantly even if it has been repaired.

• **Tip 2:** To feel a chip easily, gently move your finger around the entire surface of an object. Always double-check the tips and base of an angel's wings. They are vulnerable to chipping and breaking off easily.

• **Tip 3:** Price tags sometimes get so sticky that they can ruin any object. If you are considering making a purchase, you may want to ask the vendor to carefully remove his price tag so that the exact condition is disclosed.

• **Tip 4:** Sunlight can cause *permanent* discoloration to plastic or plush materials if an object is exposed over a significant period of time.

• **Tip 5:** If an item is made up of multiple parts, take the time to make sure all pieces are accounted for. There is nothing more disappointing then putting together a puzzle that has pieces missing.

Keep in mind that if a slight imperfection is in an inconspicuous place, then the object may still look nice on a display.

Most of us are on a budget, so every penny counts. Once you have established what type of condition the object is in, you should also estimate a fair price. I usually rate the object first on rarity, then on condition. If an object were rare, I would probably buy it at any price even with slight imperfections. However, if an object is common, I may wait until I can find it somewhere in mint condition.

The condition and price of an object can be determined with the matrix below. As you can see, an object that is in fair condition will be valued at one-half of an object in mint condition. The price examples give relative values.

Grade	Condition	Definition	Price Example
1-4	Poor	Item shows major signs of wear. No tags and/or packaging present, i.e., noticeably broken, reglued, or discolored.	$1-4
5	Fair	Item shows minor signs of wear and has some missing components. No tags and/or packaging present, i.e., missing puzzle or game pieces.	$5
6	Good	Item has been used and shows minor signs of wear. No tags and/or packaging present, i.e., small chip in an inconspicuous area or very slight crazing.	$6
7	Very Good	Item has been used but is still pristine. No tags and/or packaging present.	$7
8	Excellent	Item has been gently used but is still pristine. Original tags and/or packaging may be ripped or damaged.	$8
9	Near Mint	Item has been gently used but is still pristine. Original tags and/or packaging may be unsealed and slightly worn.	$9
10	Mint	Item has never been used and is still pristine. Original tags are present and/or packaging is sealed from the factory.	$10

One last thing, vendors at flea markets and toy shows *expect* you to barter on prices. Don't be shy! If an object is priced too expensively for the condition that it is in, let the vendor know in a diplomatic manner. If your criticism is warranted, the vendor will often reduce his asking price. Best of luck in your hunting endeavors.

Chapter 1
Household

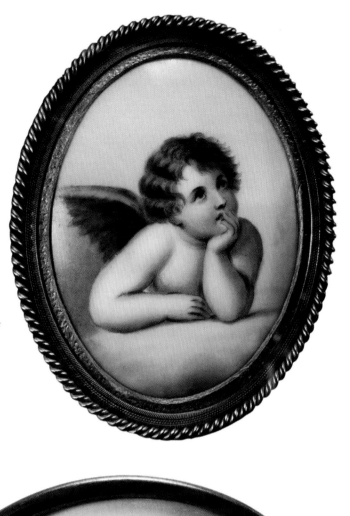

Plaque, porcelain. Manufacturer unknown, N/A. Raphael's red winged angel. 3.5" tall. $225+. *Author's note:* Value will increase if piece is marked Limoges.

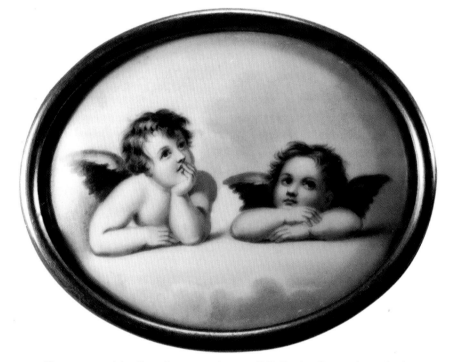

Plaque, porcelain. Manufacturer unknown, N/A. Raphael's angels are looking up at the clouds. 2.5" tall. $225+. *Author's note:* Value will increase if piece is marked Limoges.

Plaque, porcelain. Manufacturer unknown, N/A. An angel delivering a pink rose to a woman. 4.5" tall. $125+. *Author's note:* Value will increase if piece is marked Limoges.

Plaque, porcelain. Manufacturer unknown, N/A. Two angels playing with a bow and arrow. 3" tall. $125+. *Author's note:* Value will increase if piece is marked Limoges.

Framed print. M.B. Parkinson, 1897. Titled: "Cupid Awake." 4.5" tall. $30-45.

Framed print. M.B. Parkinson, 1897. Titled: "Cupid Asleep." 4.5" tall. $30-45.

Framed print. Manufacturer unknown, N/A. A woman surrounded by two angels. 11.5" tall. $10-15.

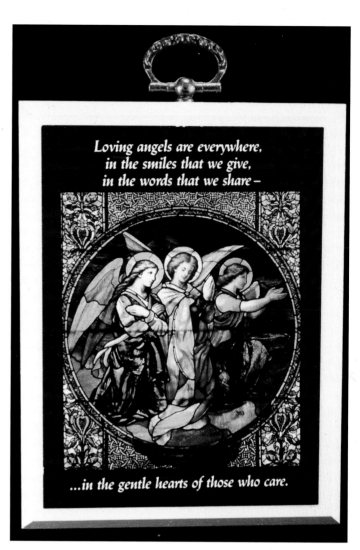

Plaque, wood. C.M.P., N/A. Paula's Mini Impressions. Caption: "Loving angels are everywhere, in the smiles that we give, in the words that we share - in the gentle hearts of those who care." 5.25" tall. $5-10.

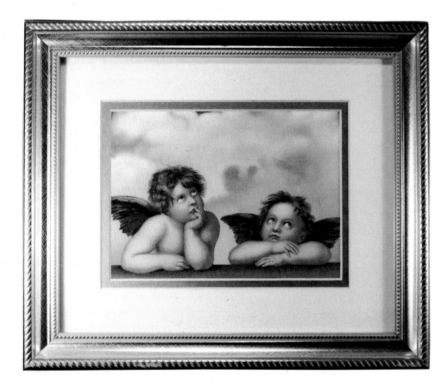

Framed print. Manufacturer unknown, N/A. Raphael's angels. 11.5" tall. $10-15.

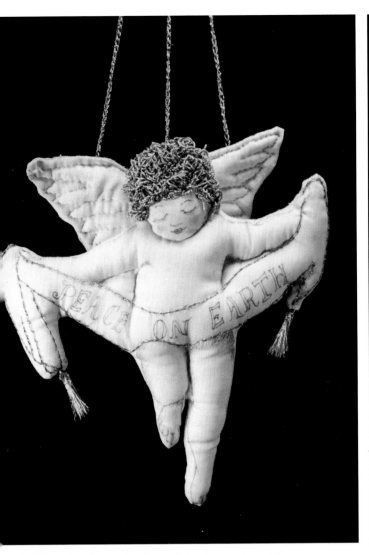

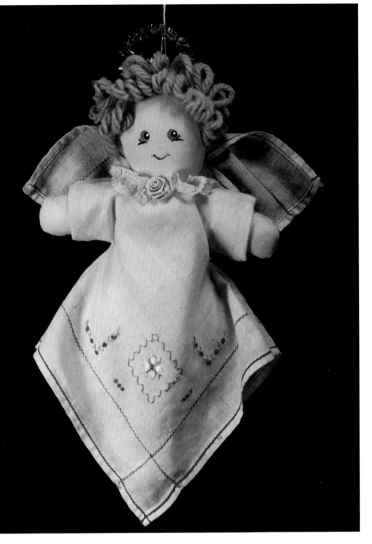

Wall hanging, fabric. Shirley Weltzler, N/A. Celestial Creations. Caption: "Peace on Earth." A golden angel hangs from a star. 15.5" tall. *Private Collection*.

Wall hanging, fabric. Artist unknown, N/A. Made with a vintage handkerchief. 8" tall. *Private Collection*.

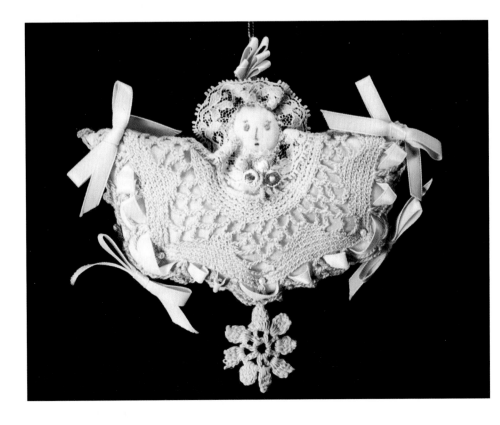

Wall hanging, fabric. Donna Boddery, N/A. Made with antique lace. 5" tall. *Private Collection*.

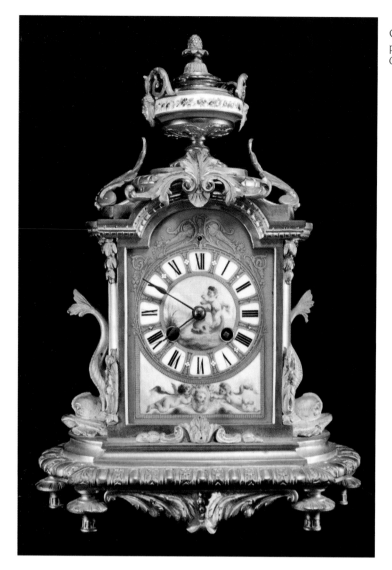

Clock, metal/enamel. Hamann & Koch (NY), 1880s. Hand-painted porcelain. 18K gold plated in bronze. French design. 12" tall. *Private Collection.*

Lamp base, metal. Manufacturer unknown, N/A. 15" tall. $150-175.

Bookends, plaster. Manufacturer unknown, N/A. 8" tall. $20-35.

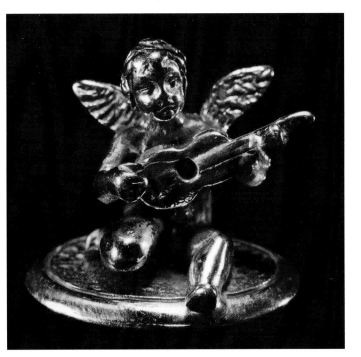

Place holder, sterling. Manufacturer unknown, N/A. An angel playing the lute. 1" tall. $100-175.

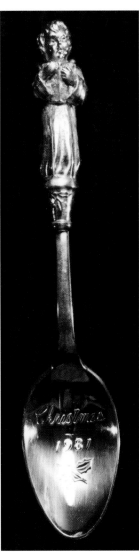

Spoon, silverplate. Reed & Barton, 1981. Caption: "The Annual Children of Christmas Collectors' Spoon. The Littlest Angel." The handle of the spoon is in the shape of an angel. 6.25" tall. $50-65.

Teacup, porcelain. Manufacturer unknown, N/A. The yellow teacup is decorated with angels. One size. $20-35.

Mug, ceramic. Torii Brand, N/A. Marked: Made in Occupied Japan. 3.5" tall. $10-15.

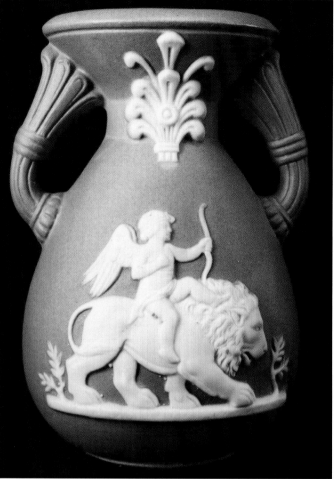

Vase, ceramic. Manufacturer unknown, N/A. 3.5" tall. $5-10.

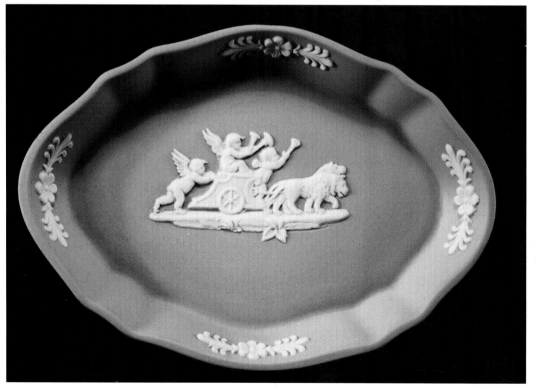

Side dish, pottery. Wedgwood, N/A. Marked: Made in England. 3" tall. $15-20.

Vase, ceramic. Manufacturer unknown, N/A. Marked: Victoria - Austria. A woman clipping Cupid's wings. 6.5" tall. $50-65.

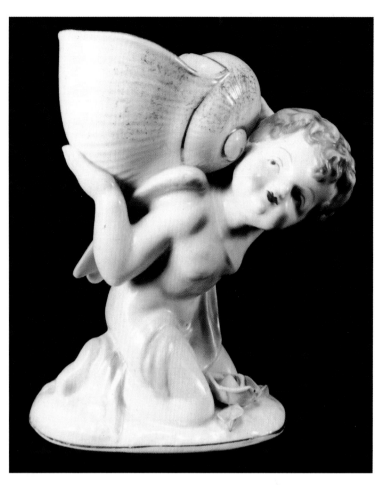

Planter, ceramic. ACME china, N/A. Marked: Made in Japan. An angel holding a seashell. 5.25" tall. $20-35.

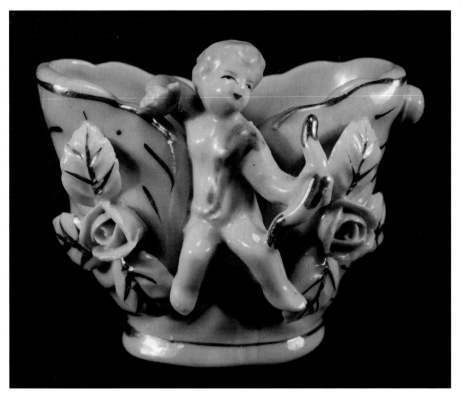

Vase, ceramic. Manufacturer unknown, N/A. Cupid on a blue bud vase. 2.5" tall. $10-15.

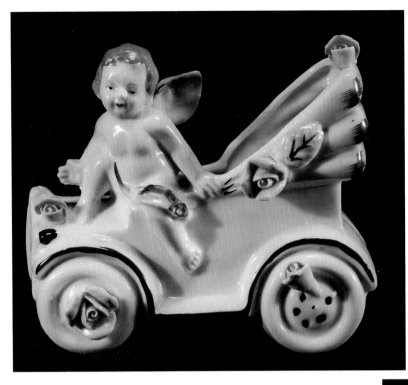

Planter, ceramic. Manufacturer unknown, N/A. Marked: Japan. An angel sitting on the hood of a car. 3.5" tall. $15-20.

Plate, bisque. Manufacturer unknown, N/A. A woman playing the harp. 6" in diameter. $30-45.

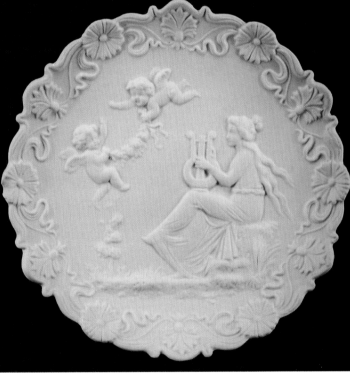

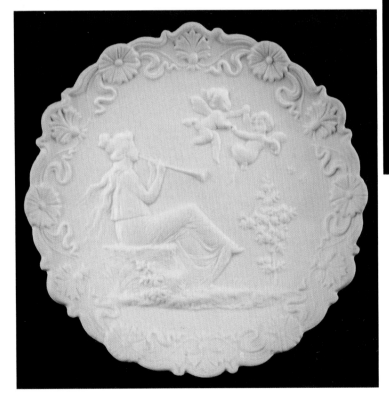

Plate, bisque. Manufacturer unknown, N/A. A woman playing a horn. 6" in diameter. $30-45.

Plate, ceramic. Manufacturer unknown, N/A. Marked: Austria. A gold and magenta border encompasses two angels. 9.5" in diameter. $40-55.

Plate, ceramic. Manufacturer unknown, N/A. Linens 'n Things Exclusive. A gold angel playing the lute. 7.5" in diameter. $15-20.

Plate, porcelain. The Gifted Line/The Hamilton Collection, 1993. Caption: "Christmas Angels from the Victorian Christmas Memories Plate Collection. [Designed] by John Grossman." Limited to a total of 28 firing days. Decorative purposes only. 8" in diameter. $30-45.

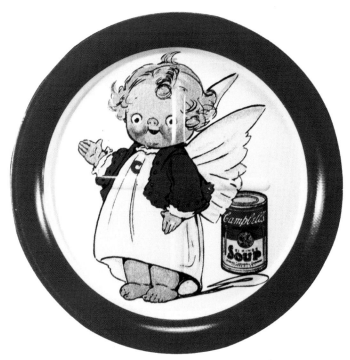

Plate, tin. Manufacturer unknown, N/A.
Caption: "Hark the Herald Angels Sing."
10" in diameter. $3-5.

Coaster, tin. Manufacturer un-
known, 1993. Campbell's Soup kid
© Campbell's Soup Co. One from
a set of six different coasters. 3.5"
in diameter. $5-10 set.

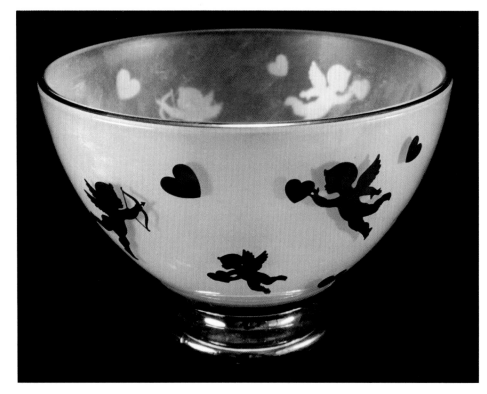

Bowl, glass. Manufacturer unknown,
N/A. Marked: Taiwan. Caption: "A
Teleflora Gift." Several gold angels
decorate this frosted bowl. 6.5" in
diameter. $15-20.

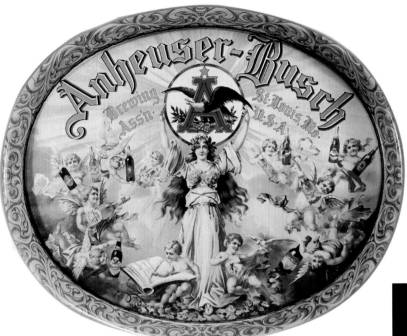

Tray, metal. Manufacturer unknown, N/A. Caption: "Anheuser-Busch. Brewing Ass'n. St. Louis, Mo. U.S.A." 12.5" long. $10-15.

Magnet, resin. Manufacturer unknown, N/A. An angel sitting on a brick wall. 4.25" tall. $5-10.

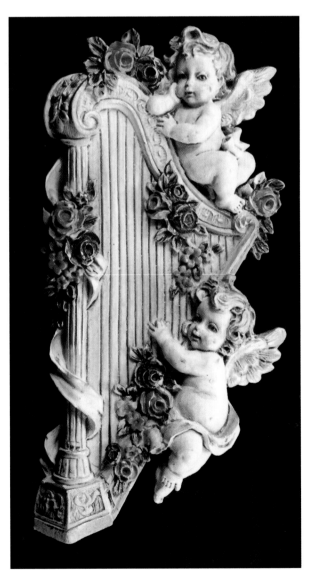

Magnet, resin. Manufacturer unknown, N/A. Two angels on a harp. 4.5" tall. $5-10.

Magnet, metal. Gallery Graphics, Inc., N/A. An angel on a red background. 3" tall. $3-5.

Magnet, wood. Manufacturer unknown, N/A. Marked: Italy. An angel playing a lute. 2" tall. $3-5.

Tin. Manufacturer unknown, N/A. An angel surrounded by stars and snowflakes. 8.25" in diameter. $5-10.

Tin. Enesco Corporation/Mrs. Grossman's Paper Co., 1983. An angel holding an archery target. 3.75" tall. $5-10.

Candy container, tin. Manufacturer unknown, N/A. Raphael's angel. Made in Switzerland. 1.75" tall. $5-10.

Candy container, fabric. Manufacturer unknown, N/A. Caption: "To my Valentine." Seven angels are embroidered on the box top. 9" tall. $20-35.

Cookie cutter, aluminum. Manufacturer unknown, N/A. 5" tall. $3-5.

Cookie cutter, plastic. Manufacturer unknown, N/A. 4" tall. $1-3.

Cookie cutter, tin. Manufacturer unknown, N/A. 2.5" tall. $1-3.

Nightlight, bisque/plastic. Manufacturer unknown, N/A. 4.5" tall. $15-20.

Brush, silver. Derby Silver Co., Pat. May 16, 1905. An angel holding a tambourine. 8.75" tall. $70-85.

Brush, silver. Victor Silver Co., Pat. May 14, 1907. Six angels surround a monogrammed heart. 8.75" tall. $50-65.

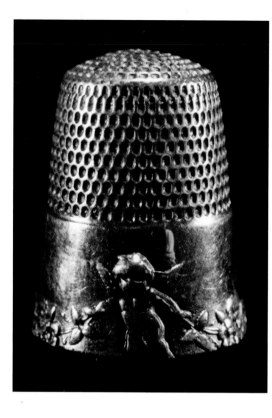

Thimble, sterling. Manufacturer unknown, N/A.
Angels around the thimble's base. .75" tall. $25-30.

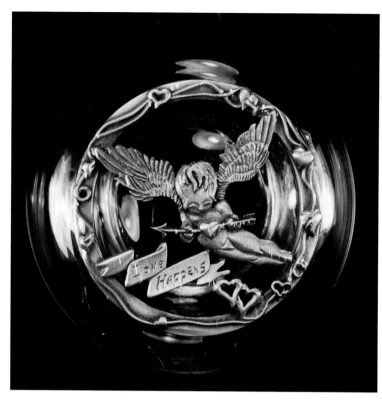

Potpourri holder, pewter/glass. Manufacturer unknown, N/A.
Caption: "Love Happens." 4.5" in diameter. $5-10.

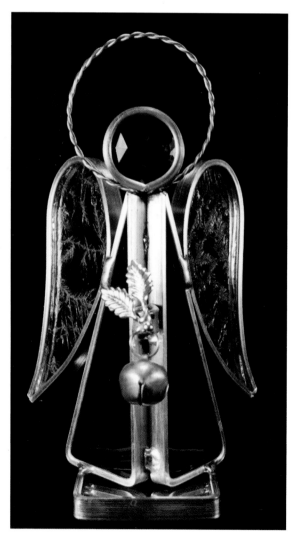

Sun catcher, glass. Manufacturer
unknown, N/A. An angel holding an
apple-shaped bell. 5" tall. $15-20.

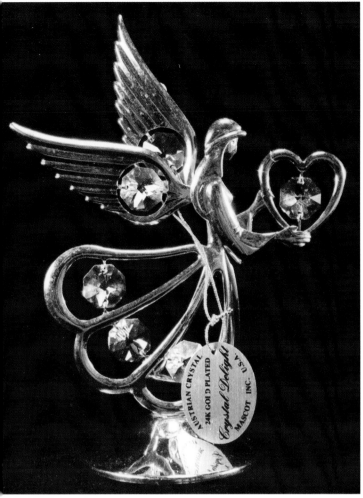

Sun catcher, brass/crystal. Mascot International, Inc., 1995. An angel holding a heart. 6" tall. $15-20.

Candle holder, metal/plastic. TDM, N/A. An angel holding a lyre. 6.25" tall. $5-10.

Candle holder, ceramic. Manufacturer unknown, N/A. Marked: Japan. Two angels are holding hands. 2.75" tall. $15-20.

Candle holder, plaster. Manufacturer unknown, N/A. Two angels playing instruments. 2" tall. $15-20 each.

Candle holder, ceramic. Manufacturer unknown, N/A. Marked: Made in Occupied Japan. An angel in a red dress playing a horn. 2.75" tall. $15-20.

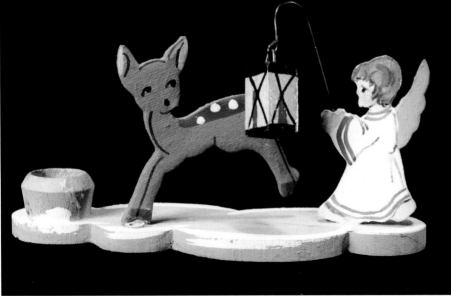

Candle holder, wood. Manufacturer unknown, N/A. An angel with a deer. 2" tall. $10-15.

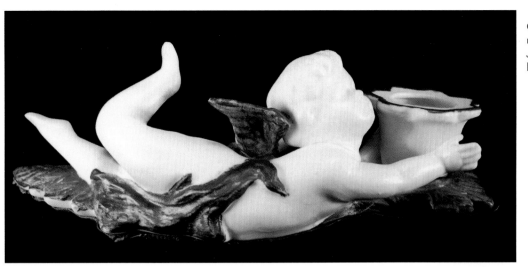

Candle holder, bisque. Manufacturer unknown, N/A. Marked: Made in Japan. An angel lying down. 6.5" long. $5-10.

Candle holder, ceramic. H.I. Co., N/A. Marked: Japan. An angel singing. 3.75" tall. $5-10.

Candle holder, porcelain. W.A., 1983. Caption: "Yuletide Angel Candle Holder. Pastel Pretties." An angel ringing a bell. 6" tall. $5-10.

Candle climber, ceramic. Manufacturer unknown, N/A.
This angel is one in a set of two. 3.5" long. $5-10 pair.

Candle holder, brass. Manufac-
turer unknown, N/A. Several
angels playing instruments. 4.5"
tall. $3-5.

Candle holder, ceramic. Manufacturer
unknown, N/A. Several angels playing
instruments. 2.5" tall. $3-5.

Candle holder, ceramic. Dollar Tree Distribution, N/A. Caption: "K' s Collection." An angel holding a basketful of stars. 3" tall. $3-5.

Candle holder, resin/glass. Manufacturer unknown, N/A. Marked: Made in China. An angel is surrounded by a glass halo. 4.5" tall. $5-10.

Statues

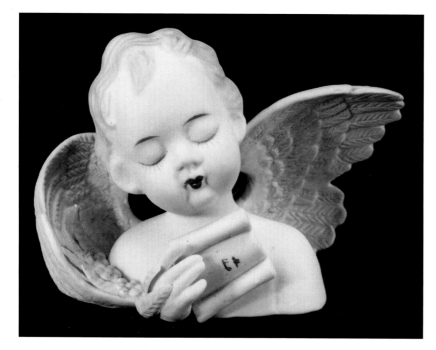

Statue, bisque. Lemora China, N/A. Marked: Made in Occupied Japan. Pink and blue wings accent this angel. 2.75" tall. $15-20.

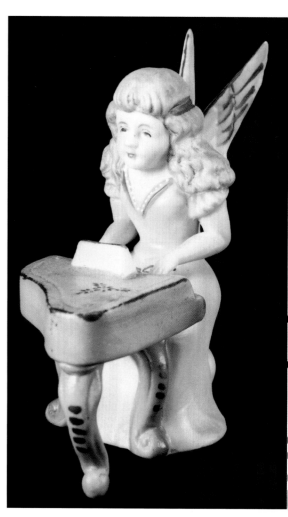

Statue, bisque. Ardalt, N/A. Marked: Made in Japan. An angel in a yellow dress playing the piano. 5" tall. $20-35.

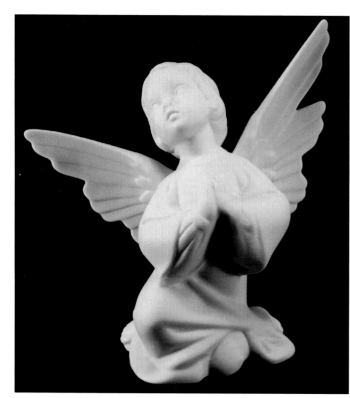

Statue, bisque. Boehm, N/A. An angel praying. 5.75" tall. $150-175.

Statue, bisque. Irish Dresden, N/A. An angel playing a gold tuba. 3.25" tall. $20-35.

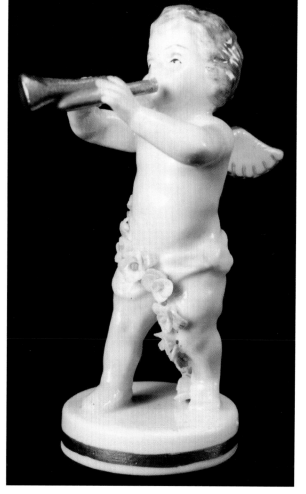

Statue, bisque. Irish Dresden, N/A. An angel playing a gold horn. 3.25" tall. $20-35.

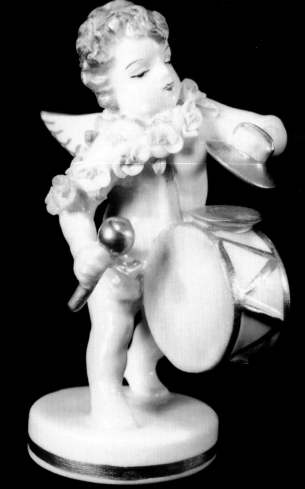

Statue, bisque. Irish Dresden, N/A. An angel playing a set of drums. 3.25" tall. $20-35.

31

Statue, bisque. Manufacturer unknown, N/A. An angel with his arms reaching out. 1" tall. $10-15.

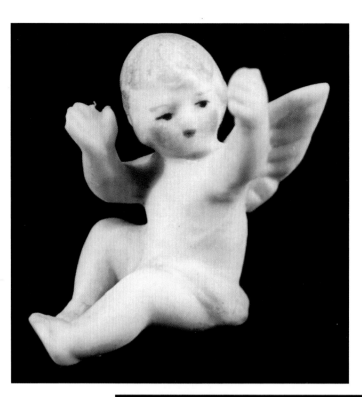

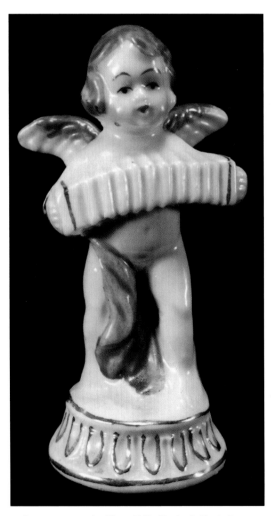

Statue, ceramic. Pico, N/A. Marked: Made in Occupied Japan. A blue winged angel playing the accordion. 3.5" tall. $15-20.

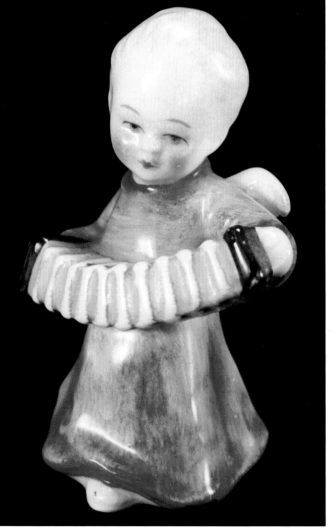

Statue, ceramic. Goebel, N/A. "V" and a bee stamped on base. Marked: Germany. An angel playing an accordion. 2.75" tall. $40-55.

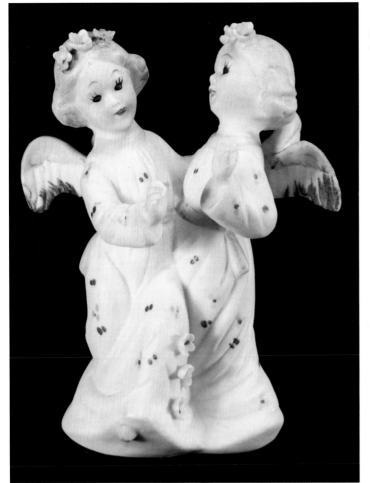

Statue, bisque. Original Arnartcreation, N/A. Marked: Japan. Two angels dancing. 3.75" tall. $15-20.

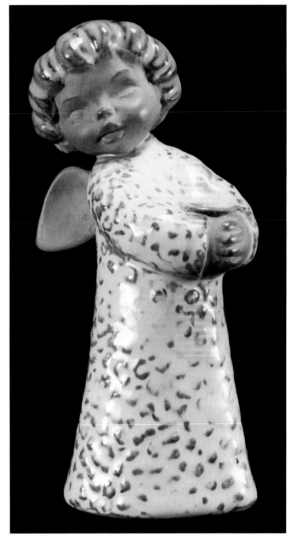

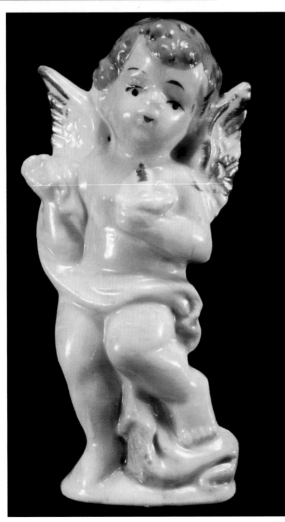

Statue, ceramic. Manufacturer unknown, N/A. Marked: Japan. An angel carrying a pink sash. 4" tall. $5-10.

Statue/candle holder, pottery. W. Goebel, 1965. "V" and a bee are stamped on the base. Marked: W. Germany. A blonde angel in a blue dress. 5" tall. $40-55.

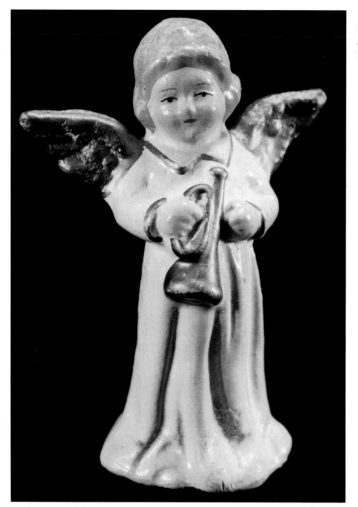

Statue, composition. Manufacturer unknown, N/A. Marked: US Zone Germany. An angel holding a horn. 2.5" tall. $15-20.

Statue, ceramic. Dollar Tree Distribution, N/A. Caption: "K' s Collection." An angel sitting in a white chair. 3.5" tall. $10-15.

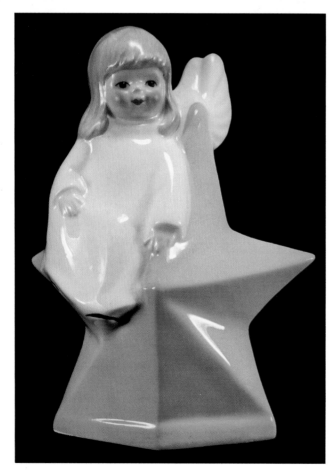

Statue, ceramic. Goebel, N/A. Marked: W. Germany. An angel sitting on a yellow star. 4.75" tall. $10-15.

Statue, ceramic. Manufacturer unknown, N/A. Unmarked. An angel sitting in a black rocking chair. 4.5" tall. $15-20.

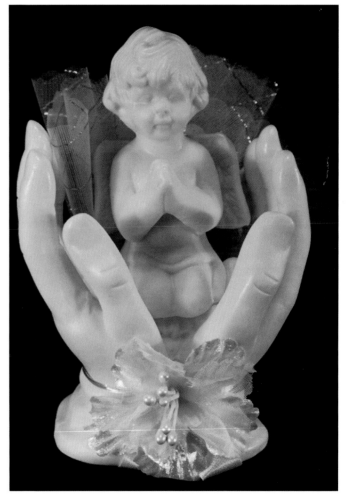

Statue, ceramic. Manufacturer unknown, 2000. Caption: "First Communion." 4" tall. *Courtesy of Sue Clark.*

Statue, ceramic. Manufacturer unknown, N/A. Marked: Japan. An angel playing a gold lute. 1.75" tall. $10-15.

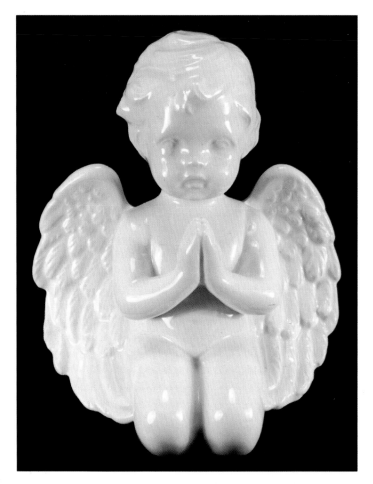

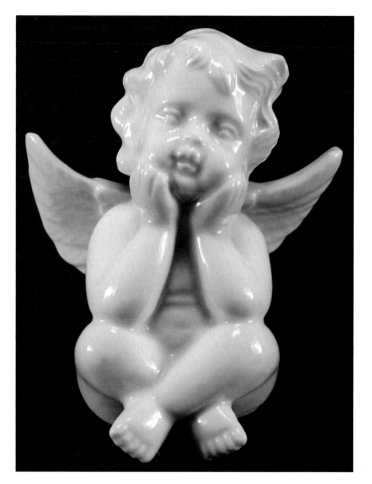

Statue, ceramic.
Manufacturer unknown,
N/A. An angel praying.
6" tall. $5-10.

Statue, ceramic. Manufac-
turer unknown, N/A. An angel
sitting. 4" tall. $5-10.

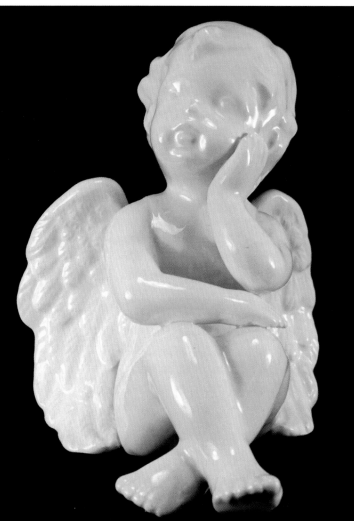

Statue, ceramic. Manufac-
turer unknown, N/A. An
angel sitting. 6.5" tall. $5-10.

Statue, bisque. Homco, N/A. An angel sitting on clouds and stars (playing the lyre). 4" tall. $10-15.

Statue, bisque. Homco, N/A. An angel sitting on clouds and stars (playing the violin). 4" tall. $10-15.

Statues, bisque. Manufacturer unknown, N/A. Three angels standing. 2.5" tall. $10-15 each.

Statue, ceramic. Manufacturer unknown, N/A. Marked: Made in China. An angel sitting on the moon. 4.5" tall. $5-10.

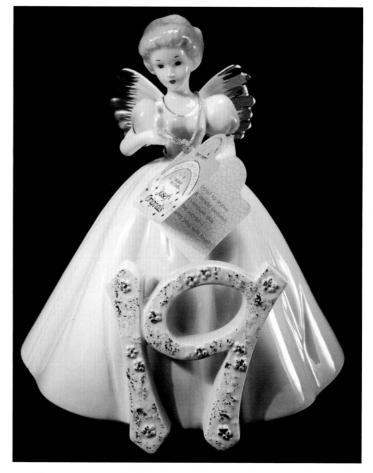

Statue, ceramic. Applause Inc., N/A. Caption: "Birthday Girls. Through the Years. Josef Originals." An angel in back of the number 19. 6.5" tall. $20-35.

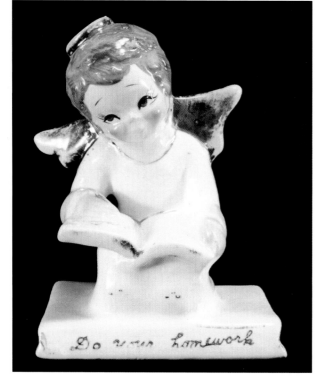

Statue, ceramic. Manufacturer unknown, N/A. Caption: "Do Your Homework." An angel writing "I believe" in his book. 4" tall. $15-20.

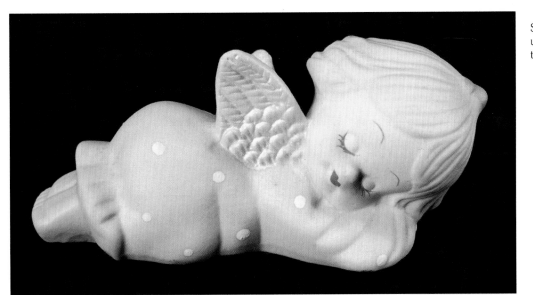

Statue, ceramic. Manufacturer unknown, N/A. An angel sleeping. 2" tall. $5-10.

Statue, bisque. Bumpkins © Falizio. An angel praying. 3.25" tall. $10-15.

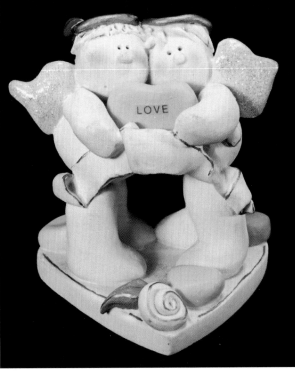

Statue, resin. Sprinkles © Nancye Williams, 1997. Caption: "I Love You." Two dough-like angels holding a heart. 2.75" tall. $5-10.

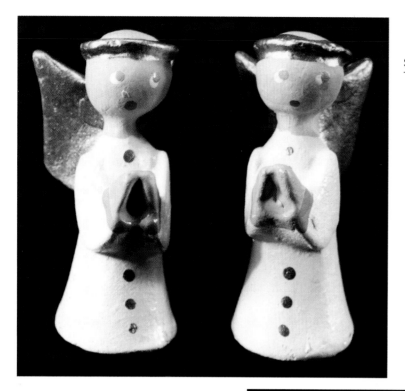

Statues, plaster. Manufacturer unknown, N/A.
Two angels praying. 2" tall. $15-20 each.

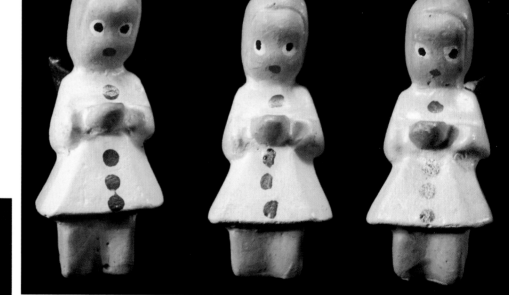

Statues, plaster. Manufacturer unknown, N/A. Three angels praying. 1.75" tall. $15-20 each.

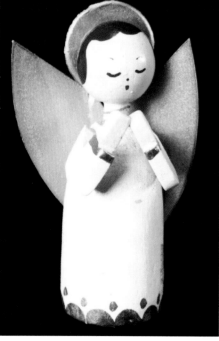

Statue, wood. Manufacturer unknown, N/A. An
angel praying. 3" tall. $3-5.

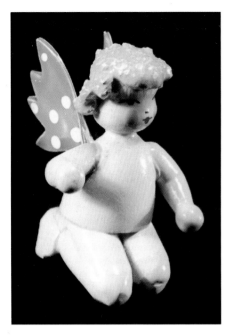

Statue, wood. Manufacturer unknown, N/A.
An angel with polka-dot wings. 1.75" tall.
$15-20.

Statues, wood. Manufacturer unknown, N/A. Three angels singing. 1.75" tall. $10-15 each.

Statues, wood. Manufacturer unknown, N/A.
Marked: Italy. Four angels have joined hands in a
circle. 2" tall. $5-10.

Statue, wood. Manufacturer unknown, N/A. An angel holding a shepherd's hook. 3.5" tall. $10-15.

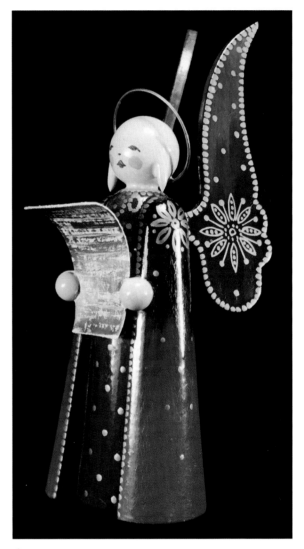

Statue, wood. Wuk, N/A. Marked: Made in Germany. An angel holding sheet music. 5" tall. $20-35.

Statue, resin. Demdaco, 2000. Designed by Sue Lordi. Caption: "Willow Tree. Angel of Learning." An angel with wire wings. 5" tall. $15-20.

Bells

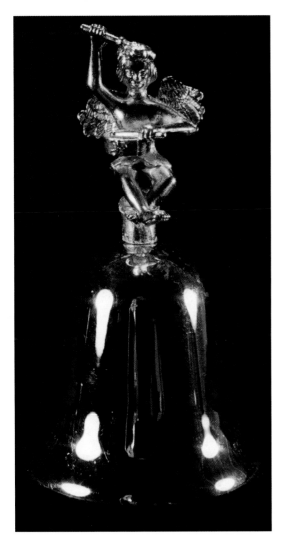

Bell, gold and silver-plated brass. FWC a Division of Frederick Atkins, Inc., N/A. Marked: China. An angel playing the drum. 4.5" tall. $5-10.

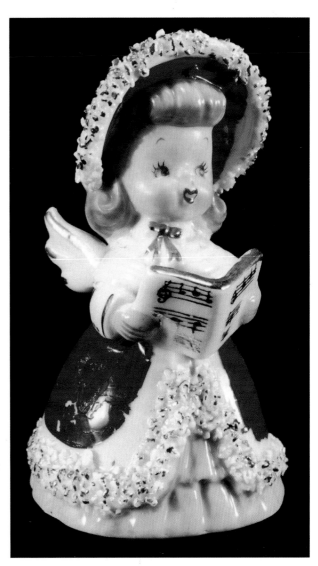

Bell, ceramic. Lefton, N/A. An angel holding a choir book. 4.25" tall. $15-20.

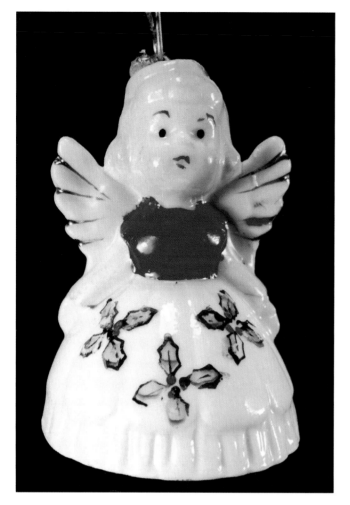

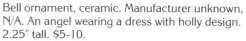
Bell ornament, ceramic. Manufacturer unknown, N/A. An angel wearing a dress with holly design. 2.25" tall. $5-10.

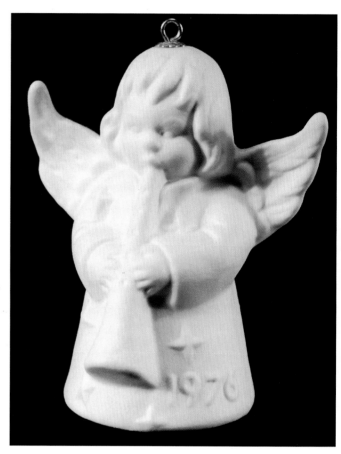

Bell ornament, ceramic. Goebel, 1976. Marked: W. Germany. An angel playing a horn. 2.75" tall. $20-35.

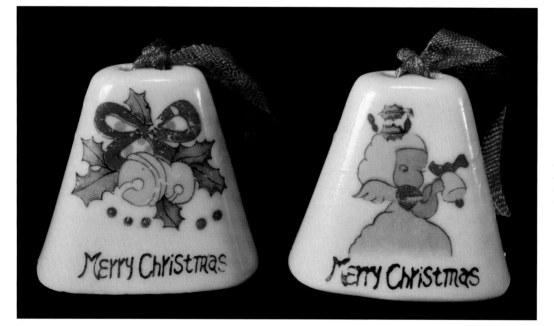

Bell ornaments, ceramic. Manufacturer unknown, N/A. Marked: Japan. One bell has an angel, the other has a holly design. 3.25" tall. $5-10 pair.

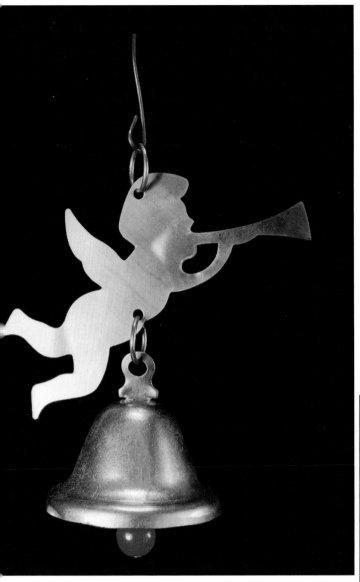

Bell ornament, brass. Manufacturer unknown, N/A. An angel playing a horn. 2.5" tall. $3-5.

Bell music box, silver-plated. Reed & Barton, N/A. Caption: "Noel Music Bell. 6th Edition." 3.5" tall. $50-65.

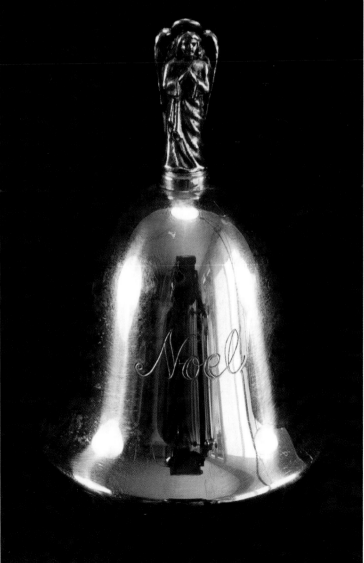

Chapter 4
Music and Trinket Boxes

Music box, metal/paper litho. Manufacturer unknown, N/A. An angel playing a flute. 3.25" in diameter. $150-175.

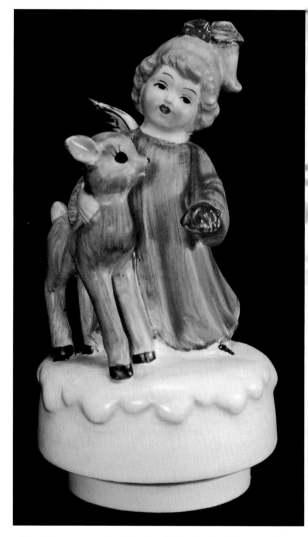

Music box, ceramic. Sankyo, N/A. Marked: Japan. An angel feeding a deer. Plays "Silent Night." 6.75" tall. $20-35.

Trinket box, milk glass. Manufacturer unknown, N/A. Three angels reading a book. 2.5" in diameter. $50-65.

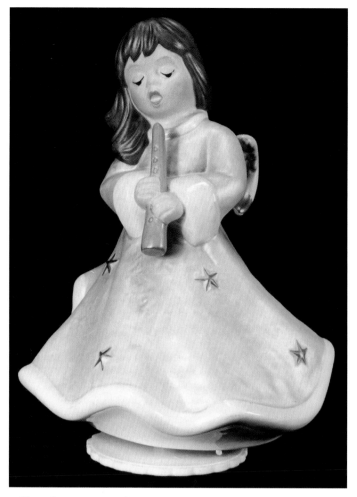

Music box, ceramic. Goebel, N/A. Marked: Weihnacht. An angel playing a clarinet. Plays "Somewhere in Time." 6.75" tall. $20-35.

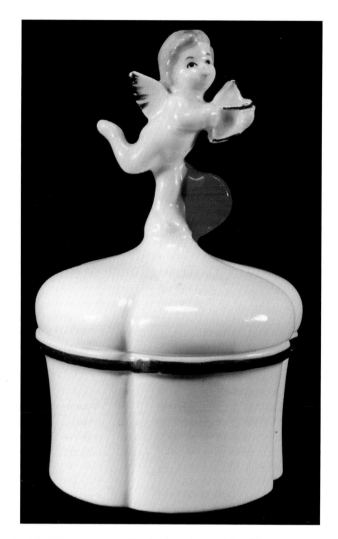

Trinket box, bone china. Enesco, 1978. Marked: Maruri Masterpiece. Cupid standing on one foot. 3.75" tall. $20-35.

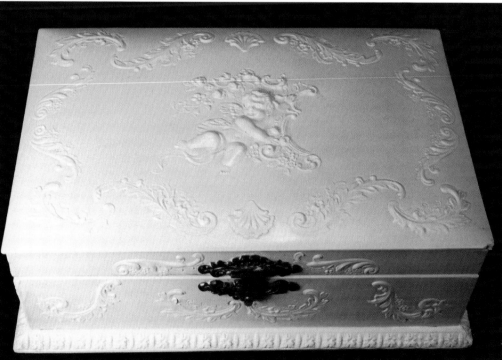

Trinket box, celluloid. Manufacturer unknown, Patented October 11, 1892. The box is lined with yellow silk. 8.5" long. $100-125.

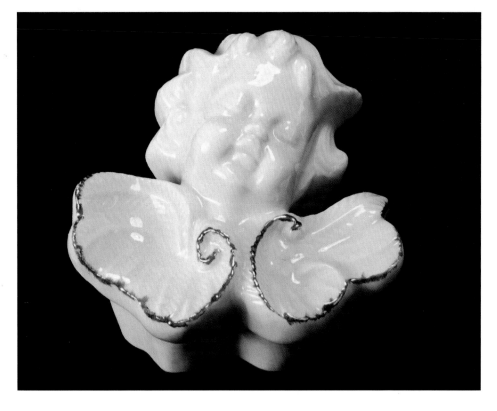

Trinket box, ceramic. Manufacturer unknown, N/A. Marked: Made in China. An angel wrapped in his wings. 4" tall. $5-10.

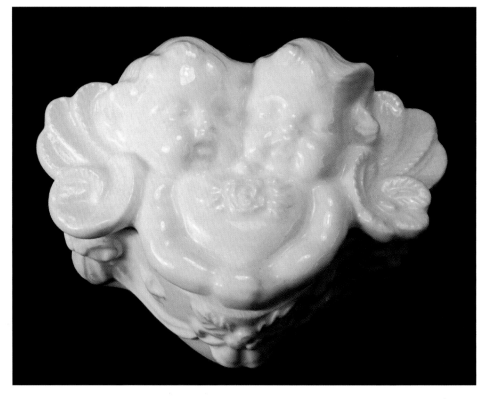

Trinket box, ceramic. Manufacturer unknown, N/A. Two angels holding hands. 3" tall. $5-10.

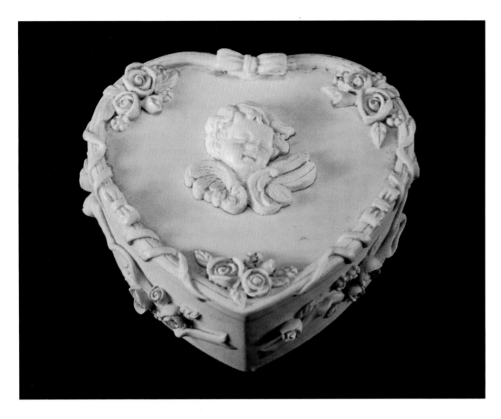

Trinket box, resin. Dezine Ltd., 1992. An angel decorates a heart-shaped box. 3.25" tall. $5-10.

Trinket box, Incolay stone. Incolay Studios Incorporated, 1973. Caption: "Incolay stone is a complex combination of minerals including those composing Onyx, Malachite, Carnelian, Jade, etc." Angels surround this shield-shaped box. 6.5" tall. $20-35.

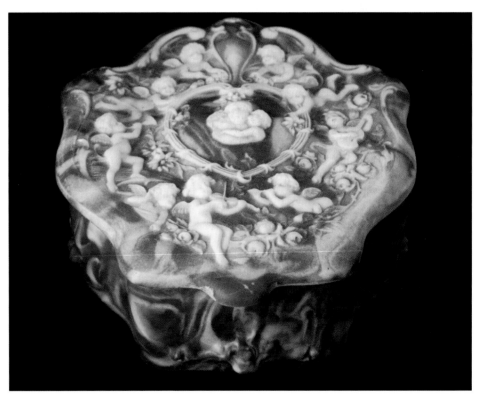

Compacts and Perfumes

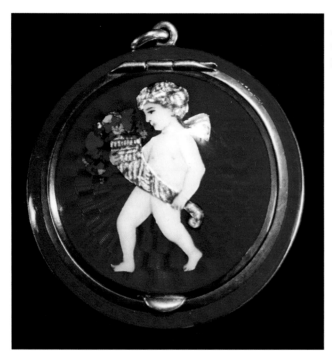

Compact, enameled sterling silver. Manufacturer unknown, N/A. An angel holding the golden horn of plenty. 1.5" in diameter. $275-300.

Powder compact, base metal with rhinestones. Estee Lauder, Dist., 1998. "Zodiac Series." April. The angel shown, Asmodel, represents courage. 2.25" in diameter. $60-75.

Powder compact, base metal with rhinestones. Estee Lauder, Dist., 1998. "Zodiac Series." January. The angel shown, Gabriel, represents joy. 2.25" in diameter. $60-75.

Powder compact, base metal. Stratton, N/A. Marked: Made in England. Two cupids look over a kissing couple. 3.25" in diameter. $100-125.

Talc powder container, cardboard. Helena Rubinstein, Inc., N/A. Caption: "Heaven-Sent Body Powder." 5" tall. $10-15.

Talc powder container, cardboard. Helena Rubinstein, Inc., N/A. Caption: "Heaven-Sent Body Powder." 4.5" in diameter. $15-20.

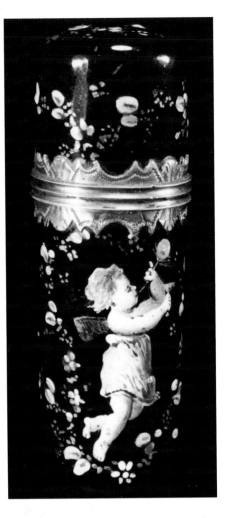

Perfume, glass/enamel. Manufacturer unknown, late 1880s. An angel blowing bubbles. 2.25" tall. *Private collection.*

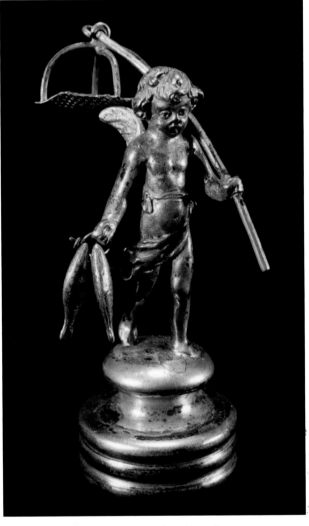

Perfume bottle top, sterling silver. Manufacturer unknown, N/A. An angel is holding fish in one hand and a net in the other. Screw top. 2.5" tall. $100-125.

Perfume, sterling. Manufacturer unknown, N/A. A perfume wand is concealed within the angel's head. 2.5" tall. $150-165.

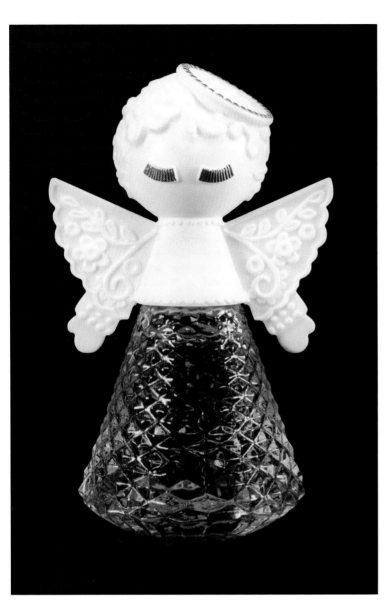

Perfume, glass/plastic. Avon Products, Inc., N/A.
Caption: "Heavenly Angel. Sweet Honesty Cologne."
4.75" tall. $5-10.

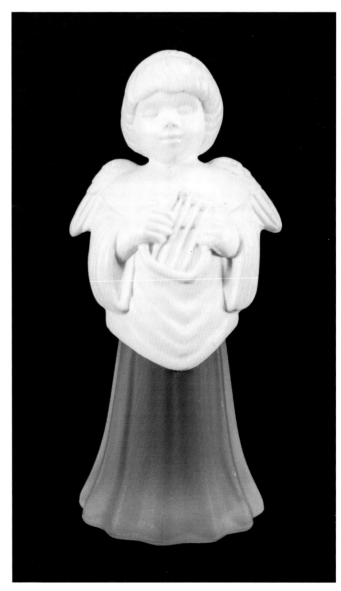

Perfume, glass/plastic. Avon Products, Inc.,
N/A. Caption: "Angel Song with Lyre. Here's
My Heart Cologne." (Unforgettable
Cologne). 4.75" tall. $5-10.

Chapter 6
Jewelry

Pin, metal/paper. Manufacturer unknown, N/A. An embossed angel within a circular pin. .75" in diameter. $20-35.

Pin, enameled gold with seed pearls. Manufacturer unknown, N/A. Here is an example of a fairy. Notice the butterfly wings. 1" tall. *Private collection.*

Pin, metal. BG, 1995 Two cupids hold a large bow. 2" tall. $5-10.

Pin, enameled sterling silver. Zarah, 2000. The angel is wrapped in purple wings. 1.75" tall. $20-35.

Pin, pewter. Manufacturer unknown, N/A. An angel wrapped in his wings. 1" tall. $15-20.

Pin, metal. Manufacturer unknown, N/A. The arrow spins to select "yes" or "no." 2" tall. $15-20.

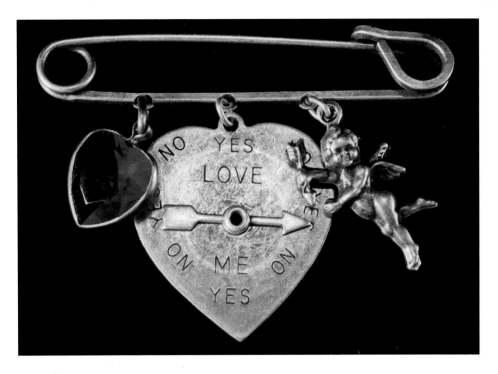

Pin, sterling. Manufacturer unknown, N/A. A cupid holding a bow. 2" tall. $50-65.

Pin, metal. Manufacturer unknown, N/A. A cupid with faux coral and pearls. 1.75" tall. $20-35.

Pin, metal. Gigi, N/A. An angel in a gold robe. 1" tall. $10-15.

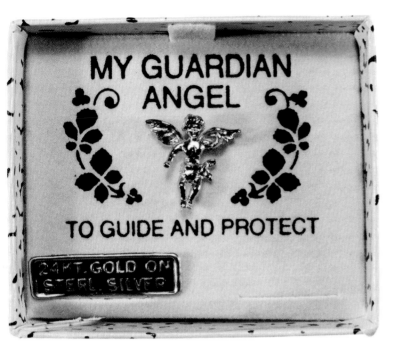

Pin, 22KT gold on sterling silver. Manufacturer unknown, N/A. Caption: "My Guardian Angel to Guide and Protect." .5" tall. $15-20.

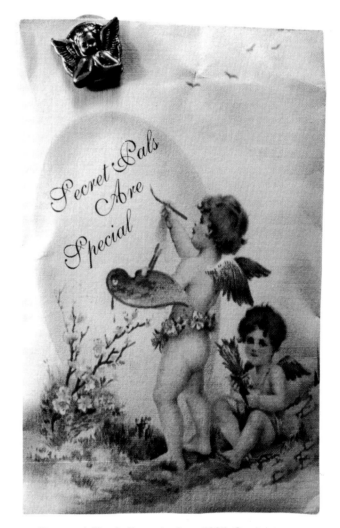

Pin, metal. Mostly Memories Inc., 1995. Caption: "Secret Pals Are Special." Mini Messages series. Complete with sachet. 3.5" tall. $3-5.

Pin, metal. Mostly Memories Inc., 1995. Caption: "Bringing Thanks." Mini Messages series. Complete with sachet. 3.5" tall. $3-5.

Pin, metal. Manufacturer unknown, N/A. An angel with crystals that represent the birthstone for May. 1.5" tall. $5-10.

Pendant, sterling. Topazio/Cazenovia Abroad Ltd., N/A. Marked: Portugal. An angel with one arm raised. 2.5" tall. $60-75.

Pendant, sterling silver. Manufacturer unknown, N/A. The angel's hair and wings are accented in gold. 2.75" tall. $100-125.

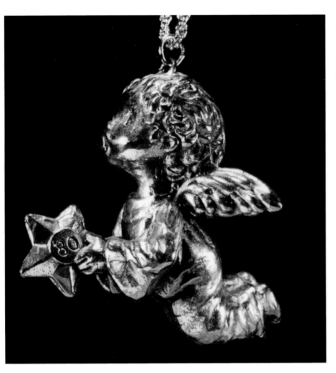

Pendant, sterling silver. Hallmark Cards, Inc, 1980. Caption: "Star Bright." Limited edition of 9,000 pieces. Little Gallery series. The angel is holding a star that is stamped with the year 1980. 1.75" tall. $150-175.

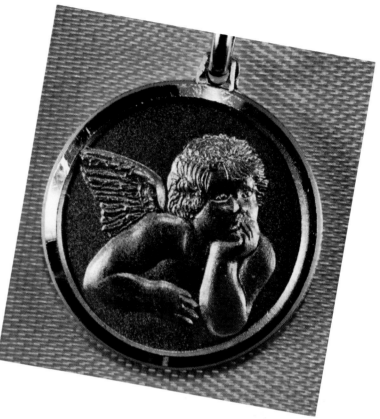

Charm, sterling silver. Manufacturer's mark stamped, "SA" within a heart, N/A. Raphael's angel. .75" in diameter. $20-35.

Charm, metal/glass. Manufacturer unknown, N/A. Cupid with a bow. 1" tall. $5-10.

Charm, sterling silver with rhinestone. Spencer Gifts, Inc., N/A. An angel with a birthstone. .75" tall. $5-10.

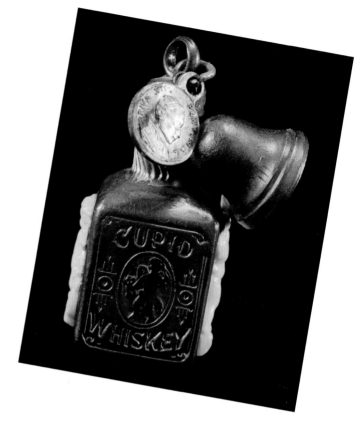

Charm, brass/plastic. Manufacturer unknown, N/A. Caption: "Cupid Whiskey." Complete with coin, bell, and three plastic figures. 1.25" tall. $15-20.

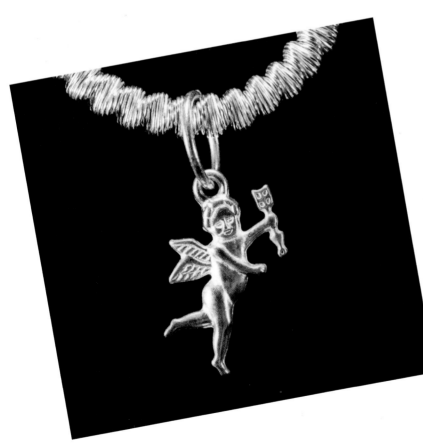

Charm, metal. Go Inc., N/A. Caption: "Charmed Sets. The fashionable way to hold up your sleeves." Two pink crystals and a silver heart are also included in set. One size. $5-10 pair.

Pin, wood. Manufacturer unknown, N/A. Marked: Italy. An angel skiing. .75" tall. $15-20.

Pin, wood. Midwest of Cannon Falls, N/A. Designed by Ilona Steelhammer. 2" tall. $10-15.

Pin, resin. Manufacturer unknown, N/A. Caption: "Joy, Peace, Love." 1.5" tall. $5-10.

Pin, plastic. Fun World Div./S. Lehman, N/A. Iridescent sparkles decorate the angel's wings. 1.75" tall. $5-10.

Earrings, pewter. Ann Clark (Mendon, VT), 1995. Vermont Collection. Caption: "Cookie Pins." 1" tall. $15-20.

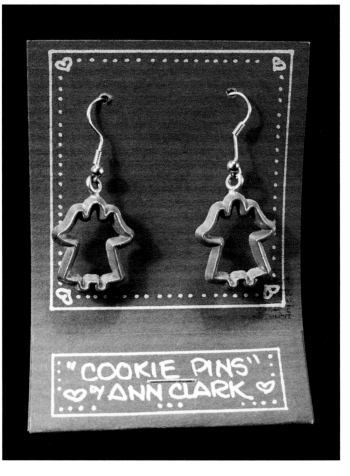

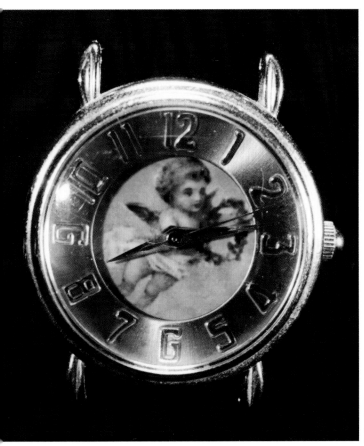

Watch, metal/glass. Manufacturer unknown, N/A. 1" in diameter. $20-35.

Pin/watch, metal/glass. The 1928 Watch Company, N/A. 2.5" tall. $100-125.

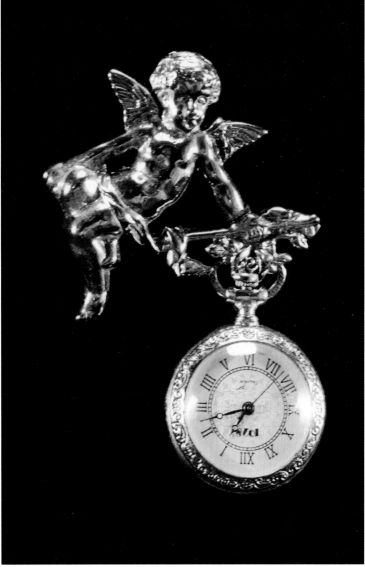

Chapter 7
Dolls and Toys

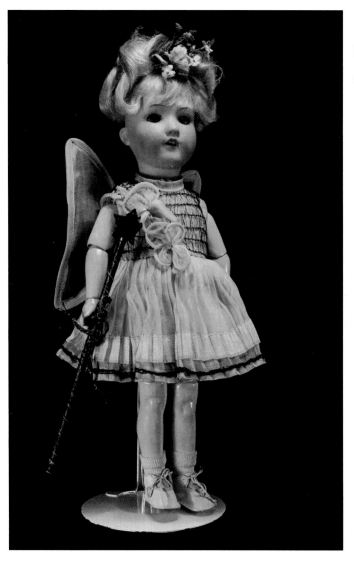

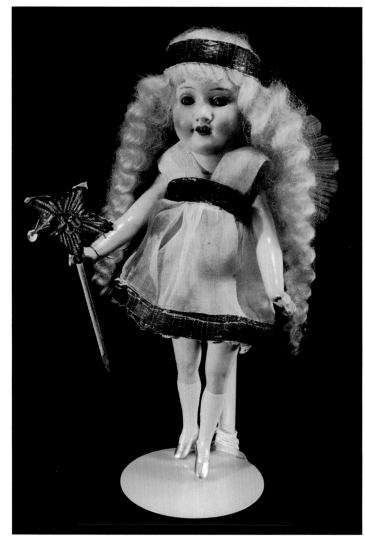

Doll, bisque/wood. Armand Marsaille, early 1900s. Marked: Germany. This angel has a gold dress with attached wings. 14" tall. $450-475.

Doll, bisque/composition. Armand Marsaille, early 1900s. Marked: Germany. This angel has wavy blonde hair and a headband. 8.75" tall. $375-400.

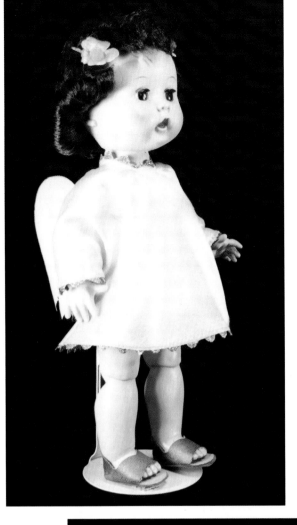

Doll, plastic. R&B Doll Co., Inc., 1955. Caption: "Littlest Angel." Complete with angel wings. 10.5" tall. $100-125.

Example of box that the Littlest Angel doll came in.

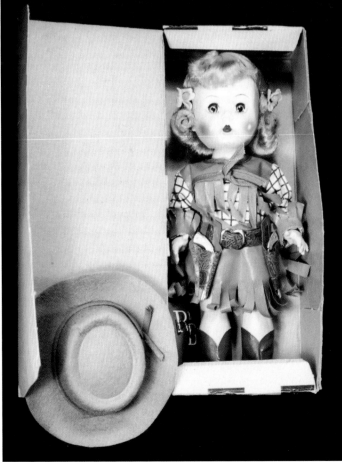

Example of cowgirl outfit for the Littlest Angel doll. Complete with two holsters, two guns, hat, and boots. One size. $150-175 (outfit only).

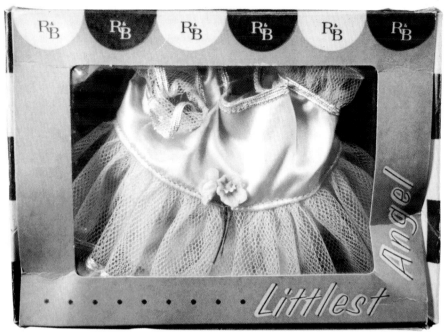

Example of ballerina outfit for the Littlest Angel doll. Complete with floral spray and pink shoes. One size. $85-100 (outfit only).

Example of checkerboard jumper for the Littlest Angel doll. Complete with matching hat, white shoes, and socks. One size. $50-65 (outfit only).

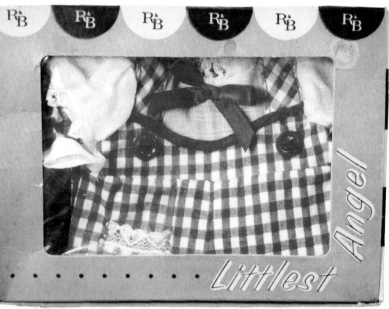

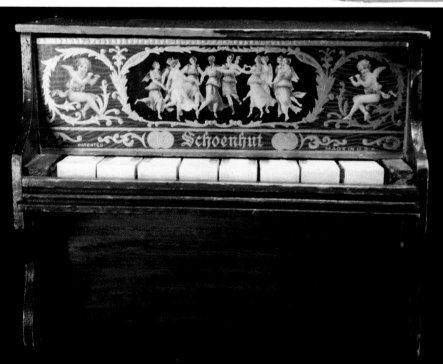

Toy piano, wood. Schoenhut, early 1900s. Complete with moveable keyboard. 7" tall. $150-175.

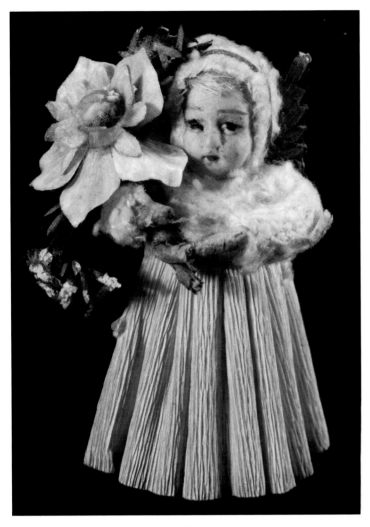

Doll, celluloid with crepe paper. Manufacturer unknown, early 1900s. Marked: Germany. This angel has gold paper wings. 2.5" tall. $150-165.

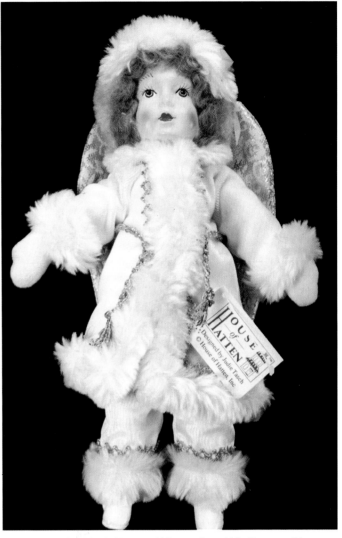

Doll, resin/material. House of Hatten, Inc., N/A. Designed by Juddie Tasch. This angel has gold wings and a white velvet coat. 10.5" tall. $15-20.

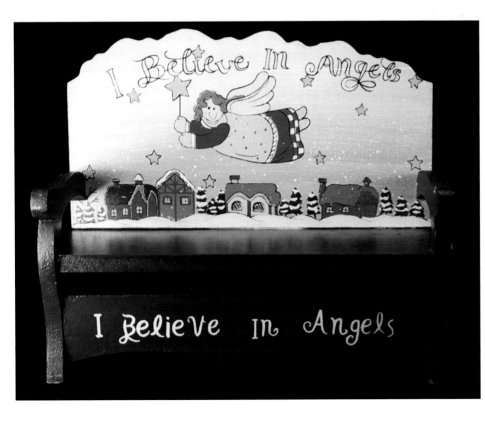

Toy bench, wood. Manufacturer unknown, N/A. Caption: "I Believe in Angels." 7" tall. $10-15.

Slide, painted glass. Manufacturer unknown, early 1900s. Caption: "Good Night to Meet Again." The slide may have been projected through a Magic Lantern. 3.25" tall. $10-15.

Game, cardboard. Parker Bros., N/A. Caption: "The Jolly Game of Old Maid." 5" tall. $20-35.

Toy, plastic. Manufacturer unknown, N/A. There is a wind-up knob on the angel's back. When wound, the wings go up and down. 2.75" tall. $3-5.

Stationery and Books

Victorian trading card. Manufacturer unknown, N/A. Caption: "Shively's 9 Cent Store. Staple & fancy dry goods, notions, hosiery, etc." Part one: Two angels are watching a butterfly. 2.75" tall. $10-15.

Victorian trading card. Manufacturer unknown, N/A. Caption: "Shively's 9 Cent Store. Staple & fancy dry goods, notions, hosiery, etc." Part two: One of the two angels tries to hit the butterfly with cupid's arrow. 2.75" tall. $10-15.

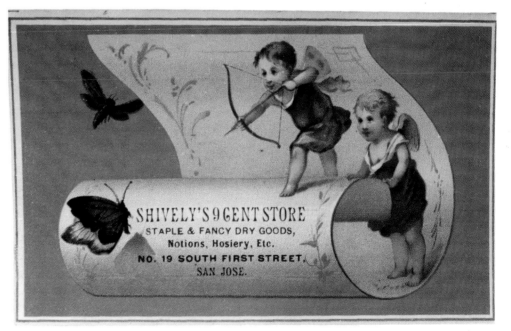

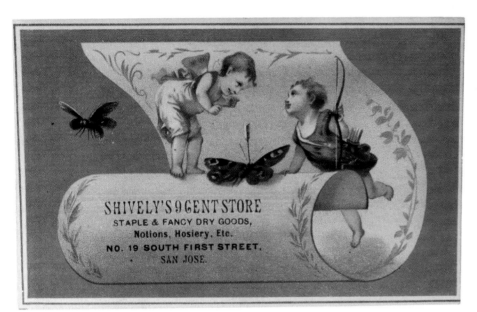

Victorian trading card. Manufacturer unknown, N/A. Caption: "Shively's 9 Cent Store. Staple & fancy dry goods, notions, hosiery, etc." Part three: Bulls eye! 2.75" tall. $10-15.

Page from a Victorian autograph book. Circa 1899. Caption: "Dear Maggie, May the angels ever guide you. May they ever round you shine. Is the wish of one that loves you. Is the happy wish of mine. Your schoolmate, Ella Leary Gillett."

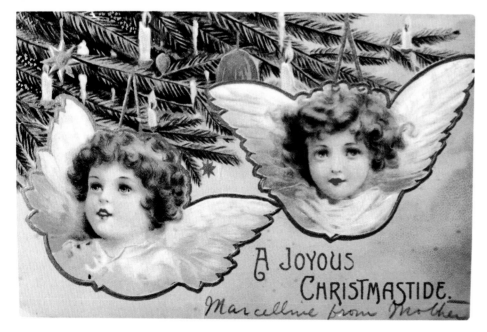

Postcard. International Art Publishing, Co., postmarked 1908. Printed in Germany. Caption: "A Joyous Christmastide." One size. $5-10.

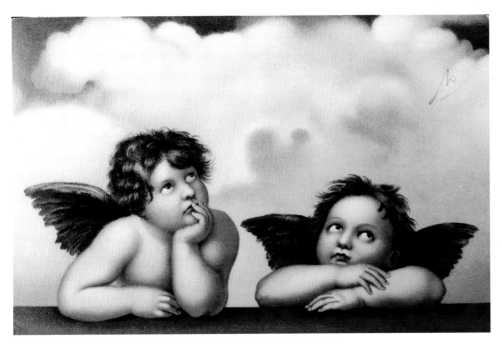

Postcard. Stengel & Co., N/A. Printed in Dresden. Raphael's angels. One size. $10-15.

Postcard. Manufacturer unknown, N/A. Printed in Germany. Caption: "To My Valentine." Two angels collecting hearts with butterfly nets. One size. $15-20.

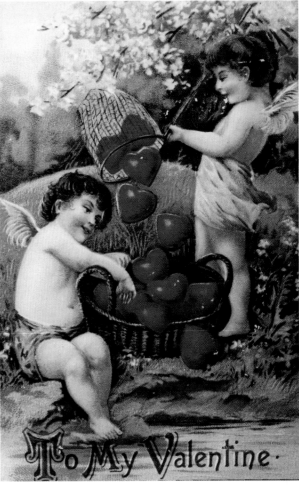

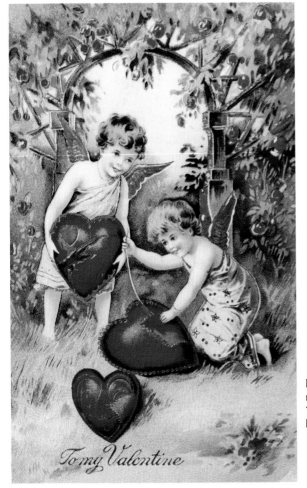

Postcard. Manufacturer unknown, post-marked 1911. Printed in Germany. Caption: "To my Valentine." Two angels mending broken hearts. One size. $15-20.

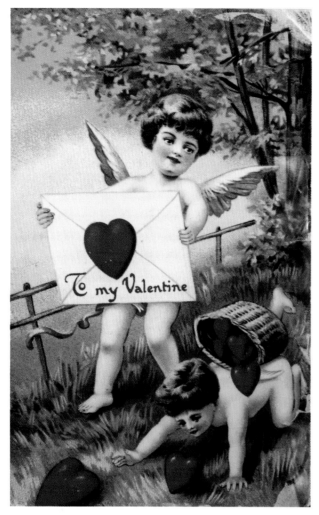

Postcard. Manufacturer unknown, postmarked 1911. Printed in Germany. Caption: "To my Valentine." Two angels collecting hearts for sealing letters. One size. $15-20.

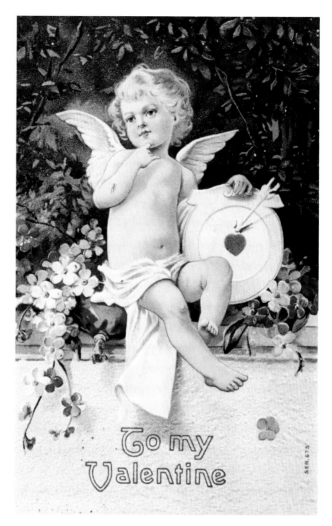

Postcard. Manufacturer unknown, postmarked 1910. Printed in Germany. Caption: "To my Valentine." An angel sits beside a target. One size. $15-20.

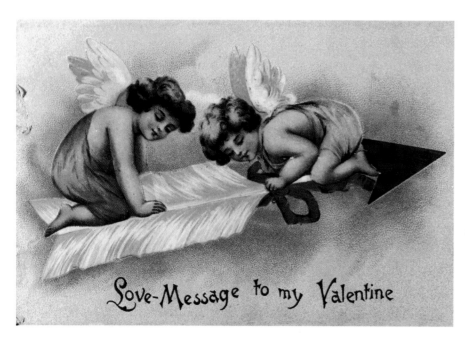

Postcard. International Art Publishing, Co., 1909. Printed in Germany. Caption: "Love-Message to My Valentine." One size. $5-10.

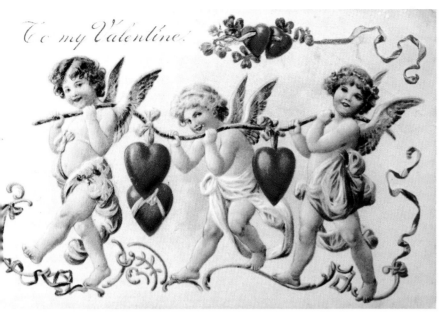

Postcard. Manufacturer unknown, postmarked 1914. Printed in Germany. Caption: "To my Valentine." Three angels carrying a vine of hearts. One size. $5-10.

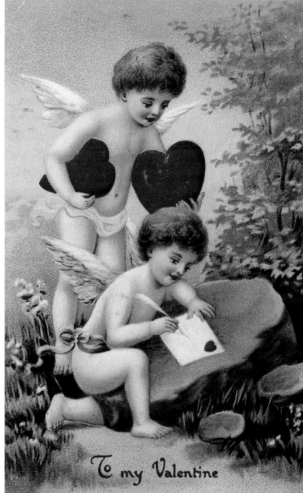

Postcard. Manufacturer unknown, postmarked 1910. Printed in Germany. Caption: "To my Valentine." Two angels writing on a rock. One size. $15-20.

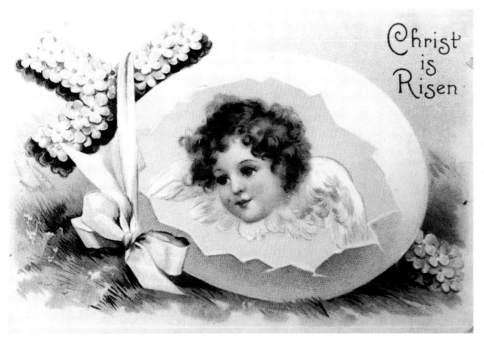

Postcard. International Art Publishing, Co., 1909. Printed in Germany. Caption: "Christ Is Risen." An angel is next to a cross made of forget-me-nots. One size. $5-10.

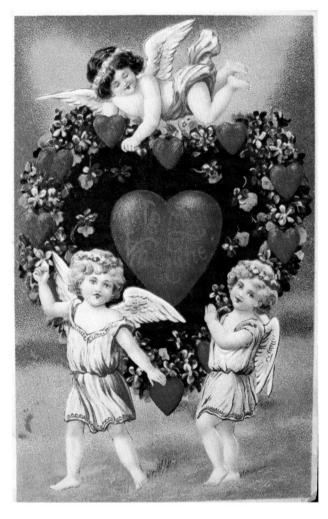

Postcard. Manufacturer unknown, postmarked N/A. Printed in Germany. Caption: "To my Valentine." Three angels holding a heart-shaped wreath. One size. $5-10.

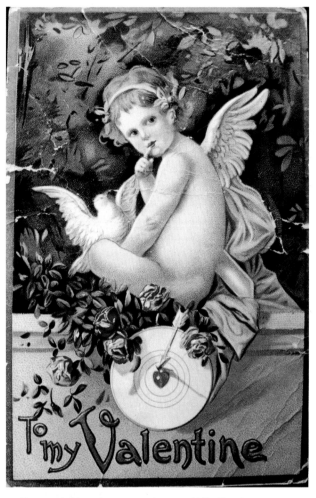

Postcard. Manufacturer unknown, N/A. Caption: "To my Valentine." An angel sits above a target. One size. $15-20.

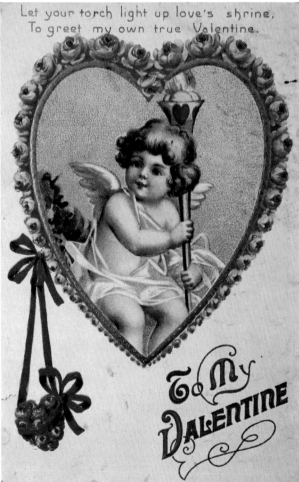

Postcard. Manufacturer unknown, postmarked 1912. Printed in Germany. Caption: "To My Valentine. Let your torch light up love's shrine, to greet my own true Valentine." One size. $5-10.

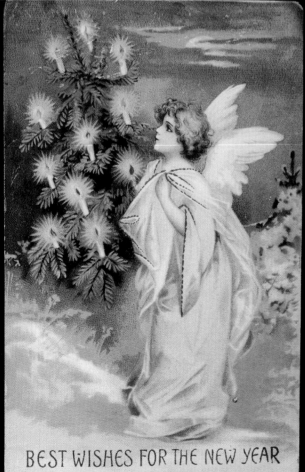

Postcard. Manufacturer unknown, postmarked 1919. Printed in Germany. Caption: "To my Valentine." A woman holding an arrow and heart. One size. $5-10.

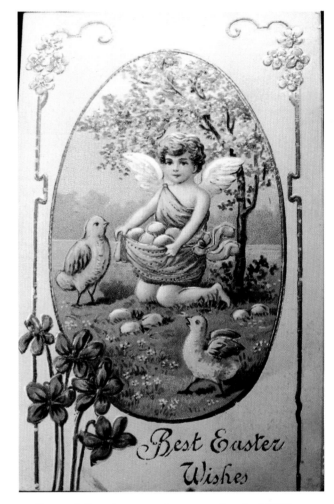

Postcard. Manufacturer unknown, postmarked 1908. Printed in Germany. Caption: "Best Easter Wishes." An angel collecting eggs. One size. $5-10.

Postcard. International Art Publishing, Co., N/A. Printed in Germany. Caption: "Best wishes for the new year." An angel holding a candle lit Christmas tree. One size. $5-10.

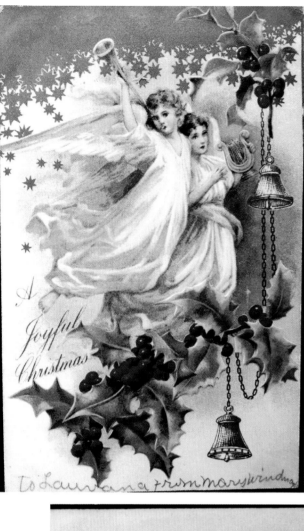

Postcard. Manufacturer unknown, postmarked 1907. Caption: "A Joyful Christmas." Two angels playing instruments. One size. $5-10.

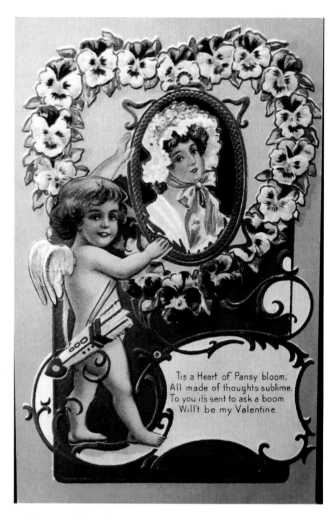

Postcard. Manufacturer unknown, N/A. Caption: "Tis a heart of pansy bloom. All made of thoughts sublime. To you it's sent to ask a boom. Will't be my Valentine." Cupid looking at a woman in a mirror. One size. $5-10.

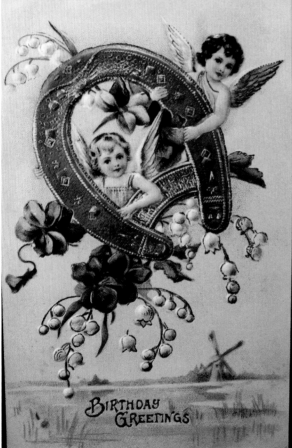

Postcard. Manufacturer unknown, N/A. Printed in Germany. Caption: "Birthday Greetings." Two angels holding a horseshoe for luck. One size. $5-10.

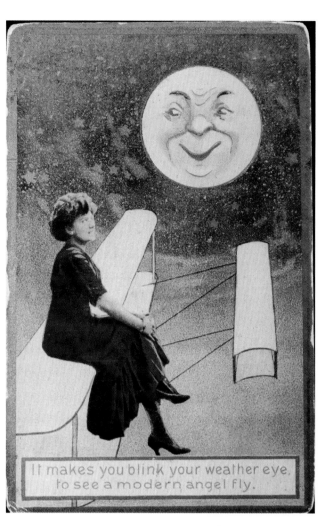

It makes you blink your weather eye,
to see a modern angel fly.

Postcard. Manufacturer unknown, postmarked 1915. Printed in U.S.A. Caption: "It makes you blink your weather eye, to see a modern angel fly." One size. $10-15.

All I need to know about life I learned from my Guardian Angel

❧ Every time you hear a bell, another angel has earned its wings ❧ Angels keep Christmas simple and always travel lightly ❧ Angels hold the miracle of holiday magic on their wings ❧ Give presence (not presents) from your heart ❧ Send a rainbow with every Christmas card ❧ Take time to smell the pine trees ❧ Say thank you for every present you receive, and mean it from the bottom of your heart ❧ It's better to give than to receive ❧ Yes, there really is a Santa Claus ❧ Good things come in small packages ❧ Better things come in no packages ❧ Rudolph really knows how to fly ❧ Always have an angel on top of your tree ❧ Christmas is not just for children ❧ Wherever there is holiday love, an angel is nearby.

Postcard. Manufacturer unknown, N/A. Caption: "All I need to know about life I learned from my Guardian Angel." Raphael's angel. One size. $1-3.

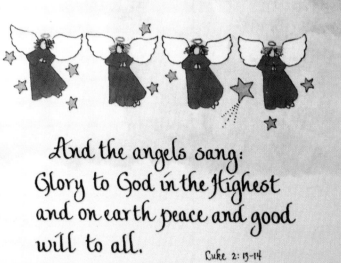

And the angels sang:
Glory to God in the Highest
and on earth peace and good
will to all.
Luke 2: 13-14

Postcard. Yours, Mine & Ours Inc., N/A. Caption: "And the angels sang: Glory to God in the highest and on earth peace and good will to all. Luke 2:13-14." One size. $1-3.

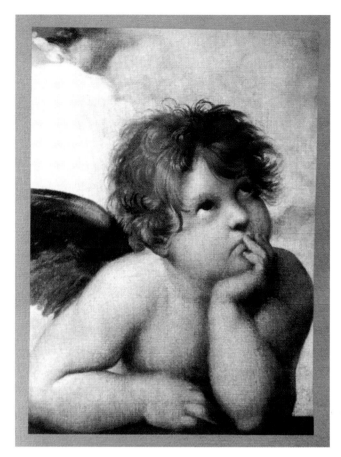

Card. B. Shackman & Co., 1992. Caption: "Greetings." A winged angel holding a sash of roses. 8" tall. $3-5.

Card. Photo Disc, N/A. Raphael's angel. 5.5" tall. $1-3.

Card. B. Shackman & Co., 1992. Caption: "My Valentine. Give me but love for love." An angel sitting on an oversized arrow. 5.75" tall. $3-5.

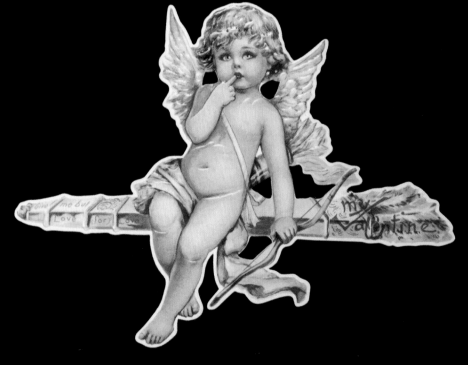

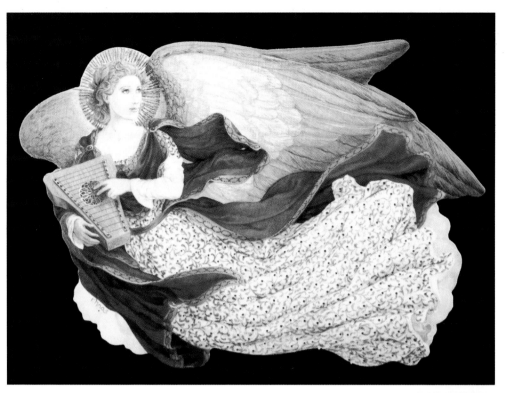

Card. Hallmark Cards, Inc., N/A. Caption: "Holiday Traditions. Angel Chorus. First in a Hallmark Christmas Card Series." Artist: Robert Allan Haas. 5.25" tall. $3-5.

Card. Photo Disc, N/A. A red winged angel playing the mandolin. 5.5" tall. $1-3.

Card. Manufacturer unknown, N/A. Promotion for Feed the Children [www.feedthechildren.org]. An angel wrapped in a sash made from roses. 6.25" tall. $1-3.

Card. Manufacturer unknown, N/A. Promotion for Feed the Children. Two angels playing instruments. 6.25" tall. $1-3.

Card. Manufacturer unknown, N/A. Promotion for Feed the Children. An angel holding a bow and arrow. 6.25" tall. $1-3.

Card. Family Line, an Allison Greetings, Inc., Co., N/A. Caption: "May your birthday be filled with magic." Artist: Peggy Jo Ackley. An angel guiding a boat full of people. 6.75" tall. $1-3.

Card. American Greeting Cards, Inc., 1999. All Art © Peter Max. Caption: "Tip Toe Floating." 7.25" tall. $1-3.

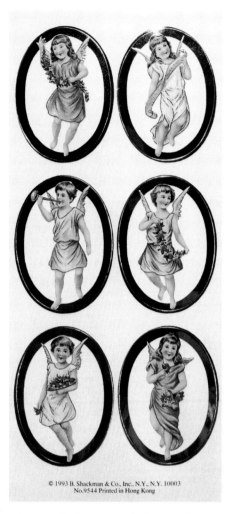

Stickers. B. Shackman & Co., 1993. Six different angels, two sheets per pack. $3-5.

Card. American Greeting Cards, Inc., 1999. All Art © Peter Max. Caption: "Spectrum Flight." 7.25" tall. $1-3.

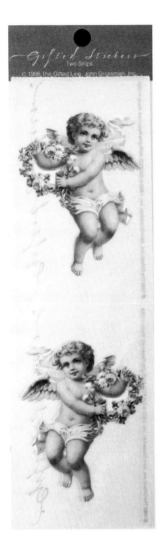

Stickers. The Gifted Line. John Grossman Inc., 1986. Two angels holding wreaths. Two sheets per pack. $5-10.

Sticker. Manufacturer unknown, N/A. A gold foil angel blowing kisses. 1.5" tall. $1-3.

Sticker. Manufacturer unknown, N/A. An angel in a green dress praying. 2" tall. $3-5 box.

Sticker. Manufacturer unknown, N/A. An angel with a lamb. 1.5" tall. $3-5 box.

Sticker. Manufacturer unknown, N/A. Two angels caroling. 1.5" tall. $3-5 box.

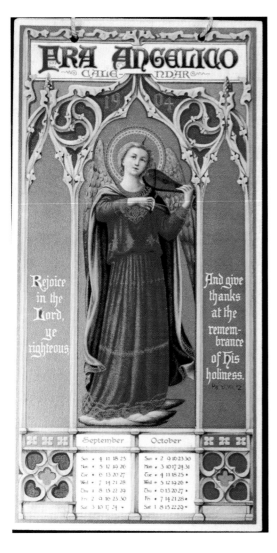

Calendar. E.P. Dutton & Co., 1904. Printed in Bavaria. Caption: "Era Angelico Calendar." 9" tall. $20-35.

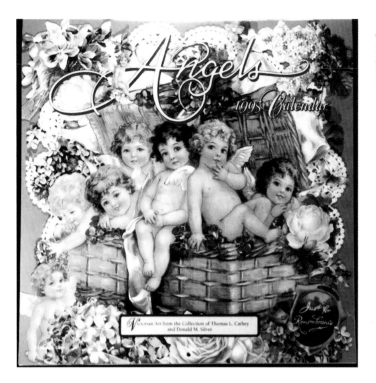

Calendar. Manufacturer unknown, 1995. Reflections Calendars. Caption: "Victorian Art from the Collection of Thomas L. Cathey and Donald M. Silver." 12" tall. $5-10.

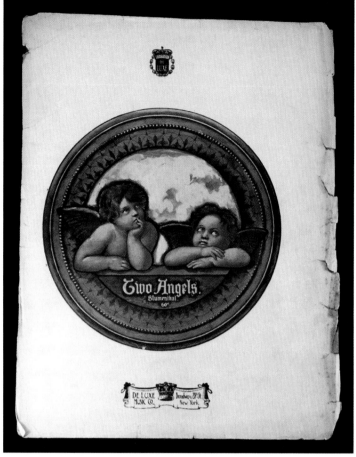

Sheet music. Deluxe Music, Co., 1907. Caption: "Two Angels. Blumenthal." Raphael's angels. 13.5" tall. $5-10.

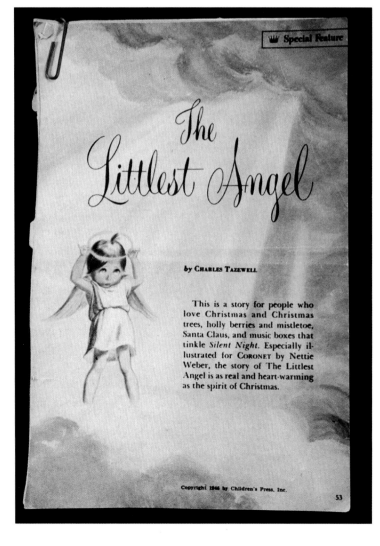

Magazine supplement. Children's Press, Inc., 1946. Caption: "The Littlest Angel. Written by Charles Tazewell. Illustrated by Nettie Weber." 7.5" tall. $1-3.

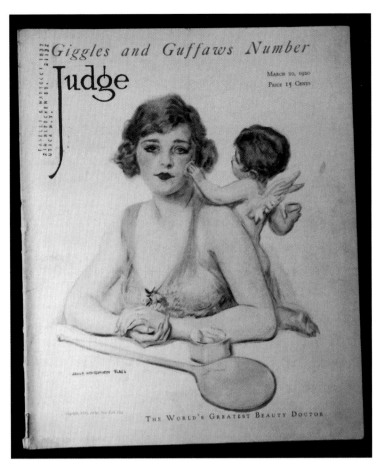

Magazine. Leslie-Judge Co., 1920. Caption: "*Judge.*
Giggles and Guffaws Number. The World's Greatest
Beauty Doctor." 11" tall. $5-10.

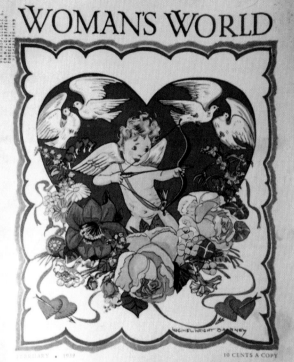

Magazine. Woman's World Publishing Co., 1939.
Caption: "*Woman's World.* Bad Blood on Old Powder
Mountain by Vingie E. Roe. Winter Care of Hands,
Needlework, Gardening, Fashions, Cookery, etc." 13.5"
tall. $5-10.

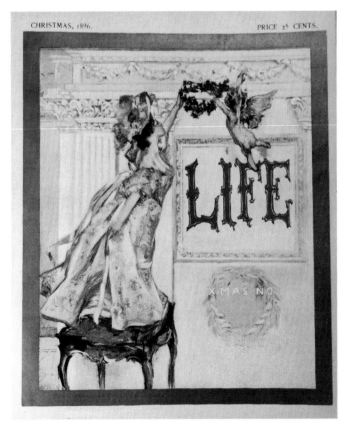

Magazine. Richard K. Fox Press, 1896. Caption: "*Life.*"
An angel and a woman hanging a garland. 10.5" tall.
$10-15.

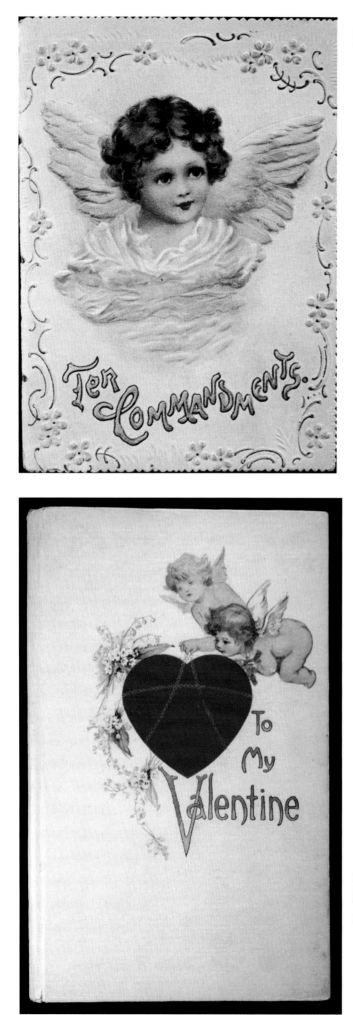

Booklet. Manufacturer unknown, N/A. Title: "Ten Commandments." 4.25" tall. $15-20.

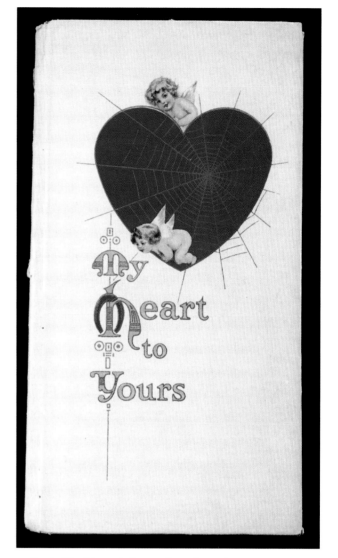

Book. The Hayes Lithographing Co., 1910. Valentine series. Title: "My Heart to Yours." Two angels overlook a spider web covered heart. 7.5" tall. $20-35.

Book. The Hayes Lithographing Co., 1910. Presentation series. Title: "To My Valentine." Two angels are putting a chain around a heart. 8" tall. $20-35.

Book. Children's Press Inc., 1960. Title: "*The Littlest Angel*." Story by Charles Tazewell. Illustrated by Katherine Evans. 8" tall. $10-15.

Book. MMA/Chronicle, N/A. Title: "*Cherubs: A Book of Ornaments*. The Metropolitan Museum of Art." Complete with five punch-out angels adapted from 18th century Neapolitan figures. 6.5" tall. $10-15.

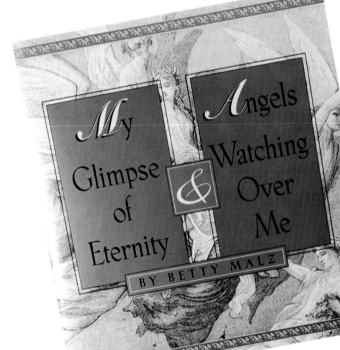
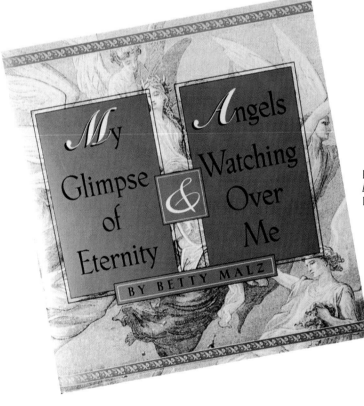

Book. Guideposts, 1977. Titled: "*My Glimpse of Eternity & Angels Watching Over Me*." Written by Betty Malz. 7.75" tall. Retail value.

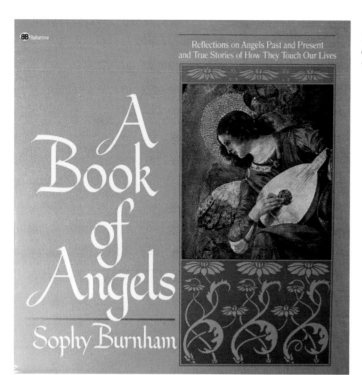

Book. Ballantine Books, 1990. Titled: "*A Book of Angels*." Written by Sophy Burnham. 7.75" tall. Retail value.

Book. Visible Ink Press, 1996. Titled: "*Angels A to Z*." Written by James R. Lewis and Evelyn Dorothy Oliver. Foreword by Andy Lakey. 9.25" tall. Retail value.

Book. Simon & Schuster, 1993. Titled: "*Angel Voices. The Advance Handbook for Aspiring Angels*." Written by Karen Goldman. 7.75" tall. Retail value.

Dreamsicles™

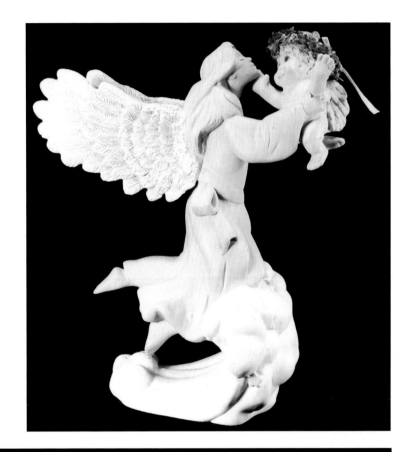

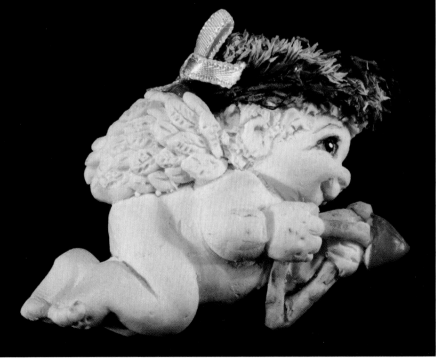

Above: Pin, metal. Cast Art Industries, Inc., 1996. Caption: "Especially for You. Wear this pin and always know you're in my heart wherever you go!" A Dreamsicle holding a heart. 1" tall. $10-15.

Bottom right: Magnet, resin. Cast Art Industries, Inc., N/A. A Dreamsicle holding a bow and arrow. 1.75" tall. $5-10.

Top right: Statue, resin. Cast Art Industries, Inc., 1995. Caption: "On Wings of Love." An angel holding a Dreamsicle. 8.5" tall. $50-65.

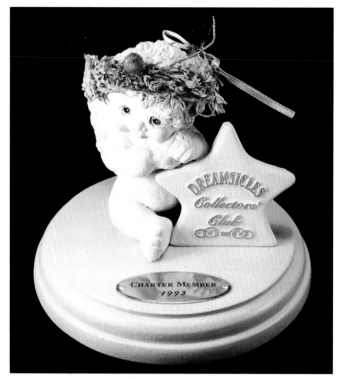

Statue, resin. Cast Art Industries, Inc., 1993. Caption: "Dreamsicles Collector's Club. Charter Member." A Dreamsicle sitting next to a star. 4.5" tall. $20-35.

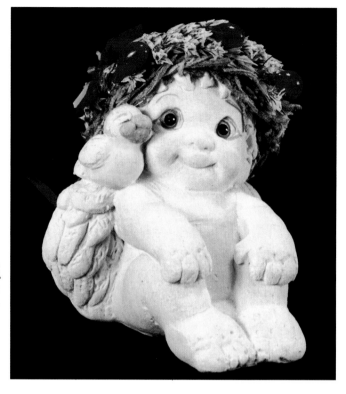

Statue, resin. Cast Art Industries, Inc., 1994. Caption: "Birdie and Me." A Dreamsicle with a bird on his shoulder. 2.75" tall. $10-15.

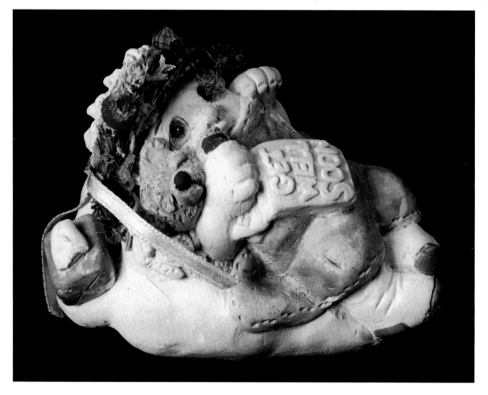

Statue, resin. Cast Art Industries, Inc., 1994. Caption: "Get Well Soon." A Dreamsicle tucked in bed. 2" tall. $10-15.

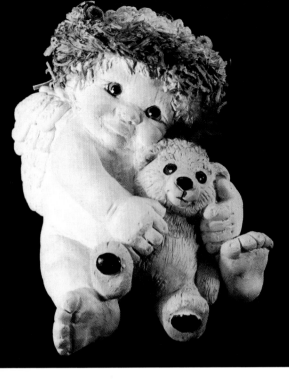

Statue, resin. Cast Art Industries, Inc., N/A. A Dreamsicle holding a teddy bear. 4" tall. $10-15.

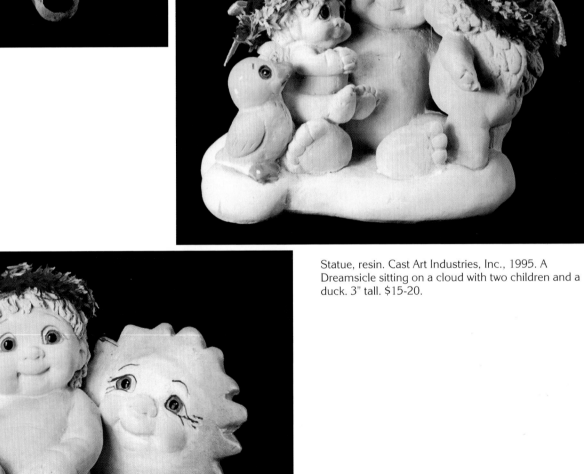

Statue, resin. Cast Art Industries, Inc., 1995. A Dreamsicle sitting on a cloud with two children and a duck. 3" tall. $15-20.

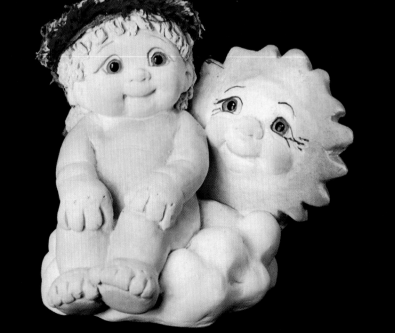

Statue, resin. Cast Art Industries, Inc., 1997. An angel sitting on a cloud while the sun peeks over his shoulder. 3.5" tall. $5-10.

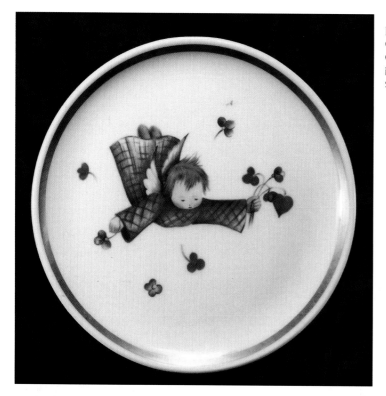

Plate, ceramic. Schmid, 1978. Marked: West Germany. Caption: "The Berta Hummel Museum Miniature Plate Collection. Reproduction of famous collector plates inspired by the art of Berta Hummel." 4" in diameter. $20-35.

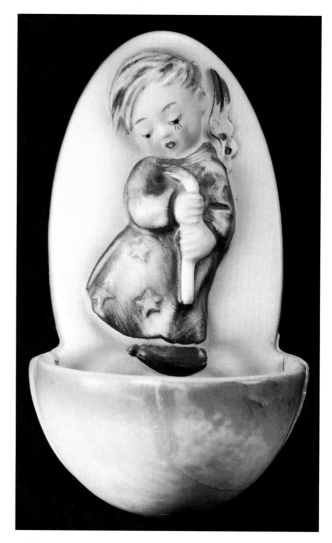

Holy water font, ceramic. M.I. Hummel, 1949. "V" and a bee stamped on base. Marked: W. Goebel. Caption: "Heavenly Angel." 5" tall. $50-65.

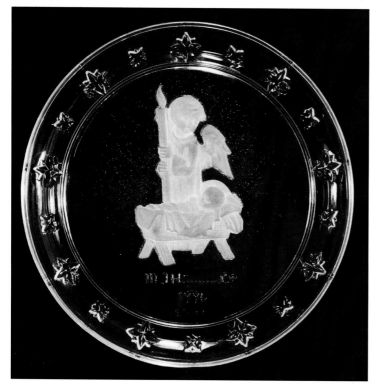

Plate, glass. Avon Products, Inc./Goebel, 1996. Caption: "M.I. Hummel 1996." An angel watches over a manger. 8.5" in diameter. $10-15.

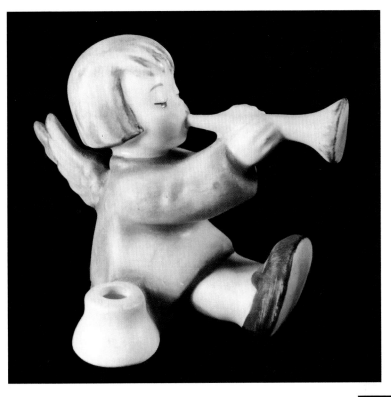

Candle holder, ceramic. M.I. Hummel, N/A. "V" and a bee stamped on base. Caption: "Joyous News." An angel playing a horn. 2.5" tall. $85-100.

Candle holder, ceramic. M.I. Hummel, N/A. "V" and a bee stamped on base. Caption: "Angel with Lute." An angel playing a lute. 2.5" tall. $85-100.

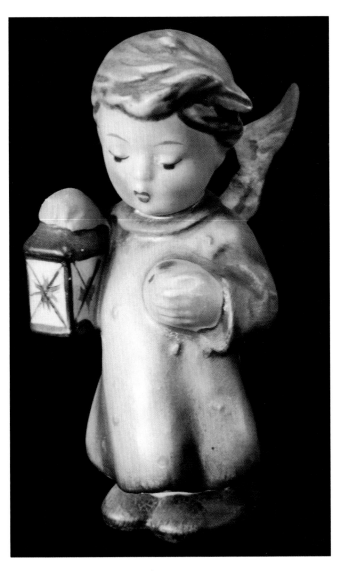

Statue, ceramic. M.I. Hummel, N/A. "V" and a bee stamped on base. Marked: W. Goebel. An angel holding a lantern. 3.75" tall. $150-175.

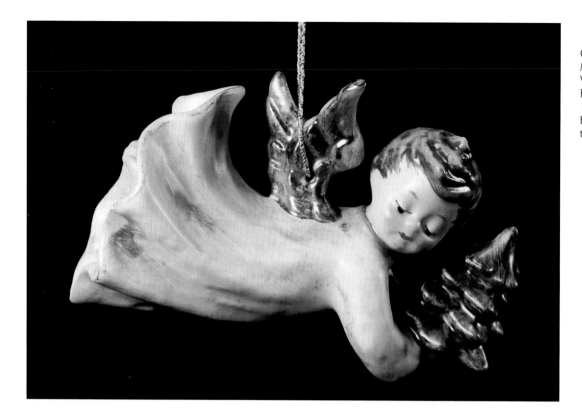

Ornament, ceramic. Goebel/ M.I. Hummel, 1988. Marked: W. Germany. Caption: "M.I. Hummel. Annual Ornament 1988. First Edition." An angel holding a Christmas tree. 3" tall. $125-150.

The box that the first edition M.I. Hummel ornament came in.

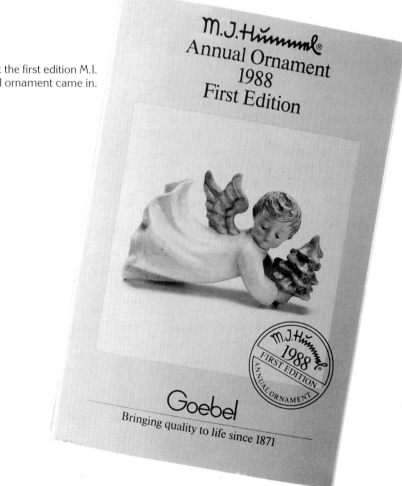

Kewpie™

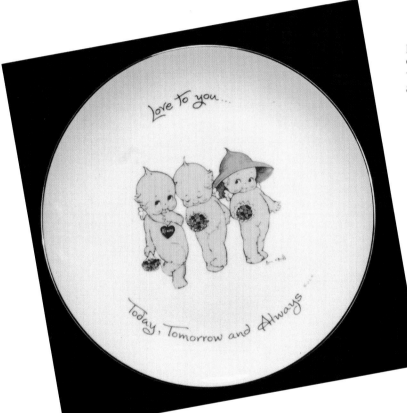

Plate, ceramic. World Wide Arts, Inc., 1973.
Collector's edition © Jos. L. Kallus. Caption:
"Love to you … today, tomorrow, and always."
8" in diameter. $20-35.

Teapot, ceramic. Manufacturer
unknown, N/A. Marked: Rose
O'Neill. Kewpie. Germany. Part of
a child's tea set. 3" tall (without
lid). $125-150.

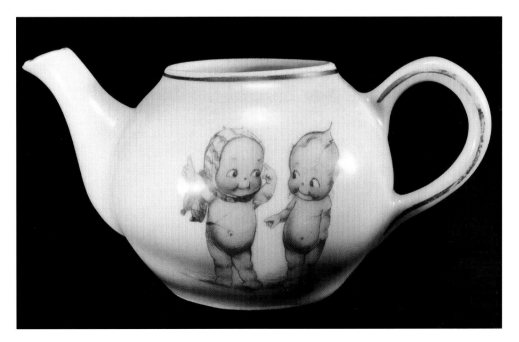

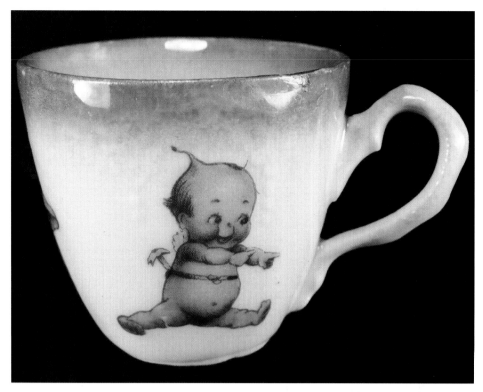

Tea cup, ceramic. Manufacturer unknown, N/A. Marked: Copyrighted Rose O'Neill Wilson. Kewpie. Germany. Part of a child's tea set. 2" tall. $75-100.

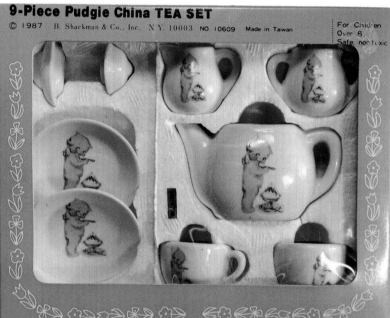

Tea set, ceramic. B. Shackman & Co., Inc., 1987. Caption: "9 Piece Pudgie [Kewpie look-alike] China [child's] Tea Set." One size. $20-35.

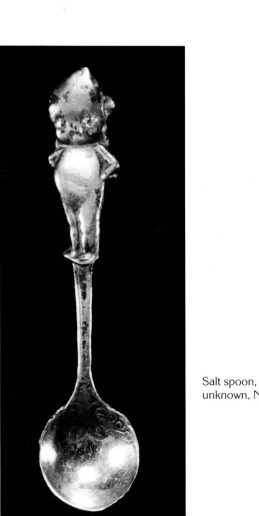

Salt spoon, sterling silver. Manufacturer unknown, N/A. 2" tall. $85-100.

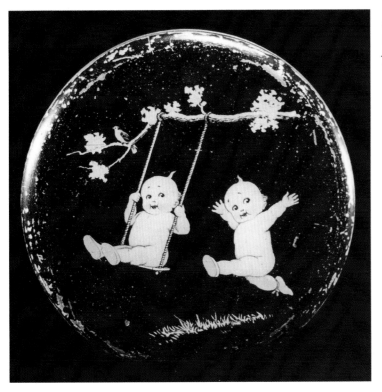

Container, tin. Manufacturer unknown, N/A. Two Kewpies with a swing. 6" in diameter. $50-65. *Author's note:* A miniature version of this container exists.

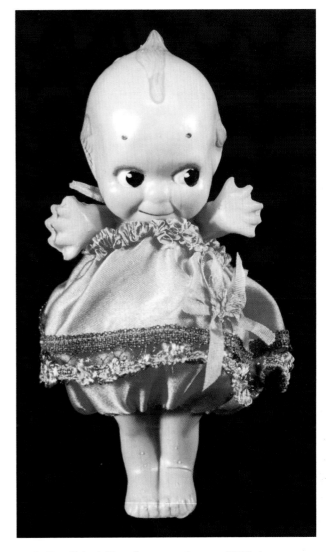

Doll, celluloid. Manufacturer unknown, 1913. A Kewpie wearing an artist-made pink dress. 5" tall. $85-90.

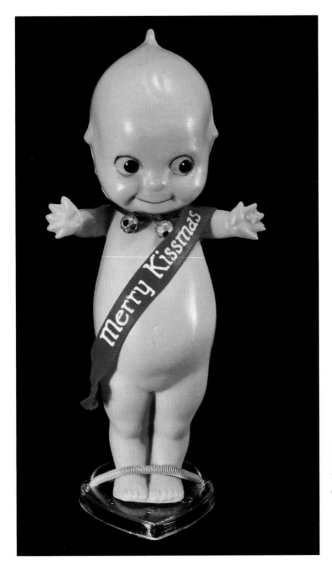

Doll, celluloid. Manufacturer unknown, N/A. Caption: "Merry Kissmas." A Kewpie wearing an artist-made sash and collar. Jointed arms. 8" tall. $165-185.

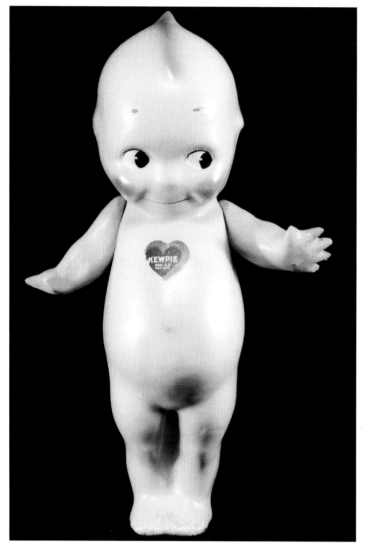

Doll, composition. Cameo (or Rex/Mutual) Doll Co., early 1900s. Marked on a heart: "Kewpie reg. US Pat. Off." Jointed arms. 8.5" tall. $150-175.

Doll, composition. Cameo (or Rex/Mutual) Doll Co., early 1900s. Marked on a heart: "Kewpie Des. & Copyright by Rose O'Neill." A Kewpie in her original pink sundress. Jointed arms. 11" tall. $225-275.

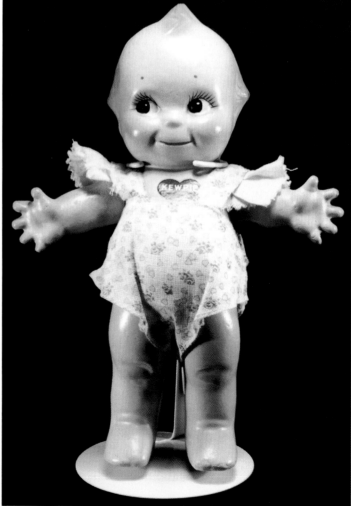

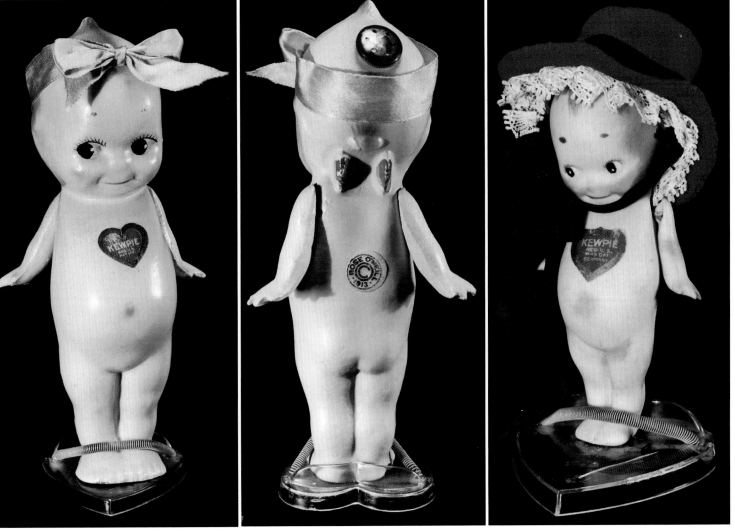

Doll/Talcum, composition. Cameo (or Rex/Mutual) Doll Co., early 1900s. Marked on a heart: "Kewpie Reg. US Pat. Off." The back of the Kewpie's head contains a spout for talc powder. 7" tall. $200-225.

A view of the talc spout that is on the back of Kewpie's head.

Doll, bisque. J.D. Kestner (or another German firm), early 1900s. Marked on a shield: "Kewpie. Reg. US Pat. Off. Germany." A Kewpie wearing an artist-made red bonnet. 4" tall. $125-150.

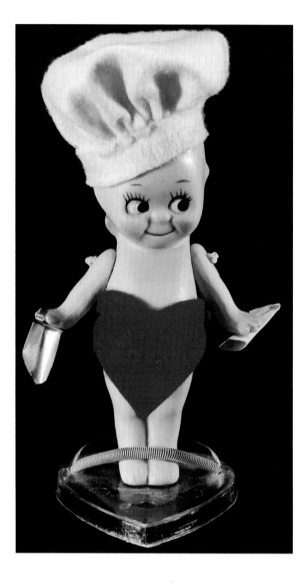

Doll, bisque. B. Shackman, N/A. A Pudgie [Kewpie look-alike] wearing an artist-made chef's hat and heart apron. 5" tall. $35-40.

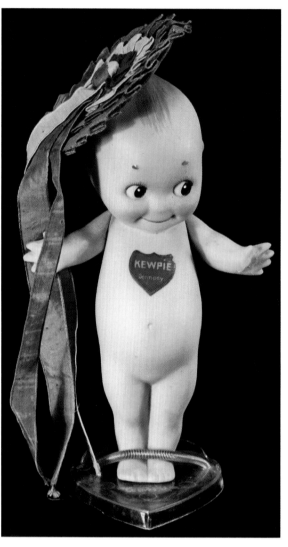

Doll, bisque. J.D. Kestner (or another German firm), early 1900s. Marked on a shield: "Kewpie. Germany." A Kewpie wearing an artist-made ribbon beret. 6" tall. $125-150.

Advertisement, cardboard. Enesco Corporation/Jesco, 1994. Caption: "Kewpie Klassics." 15.5" long. $15-20.

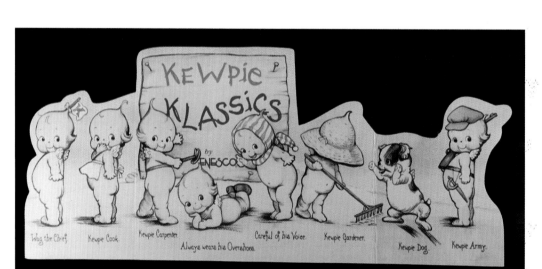

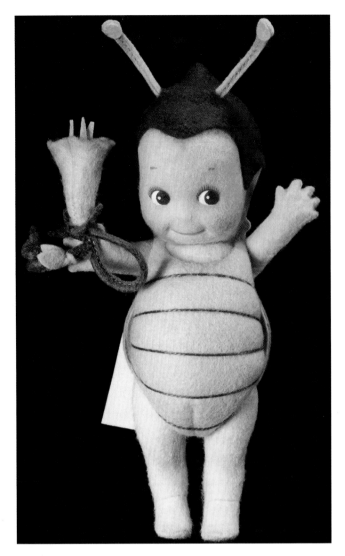

Doll, felt. R. John Wright, 1999. Caption: "Flit." Limited edition of 250 pieces. A Kewpie wearing a bug outfit. 7" tall. $500+.

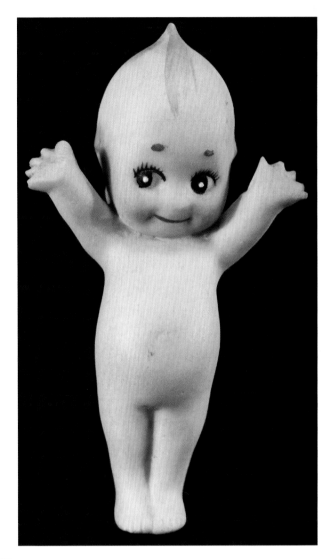

Statue, bisque. J.D. Kestner (or another German firm), early 1900s. A Kewpie with his arms wide open. 2.5" tall. $100-125.

Statue, ceramic. Enesco Corporation/Jesco, 1991. Caption: "Signature Figure. The Rose O'Neill Kewpie Collection." A Kewpie with a paintbrush and easel. 3.75" tall. $20-35.

Statue, bisque. Enesco Corporation/Jesco, 1992. Caption: "Thinker Figure." A Kewpie sitting and thinking. 3" tall. $15-20.

Statue, bisque. J.D. Kestner (or another German firm), early 1900s. Two Kewpies hugging. 3.5" tall. $200-225.

Statue, ceramic. Enesco Corporation/Jesco, 1992. Caption: "With Baby Shoe Figure." A Kewpie sitting in a shoe. 3.5" tall. $20-35.

Statue, ceramic. Enesco Corporation/Jesco, 1993. A Kewpie holding an alphabet block. 3.25" tall. $20-35.

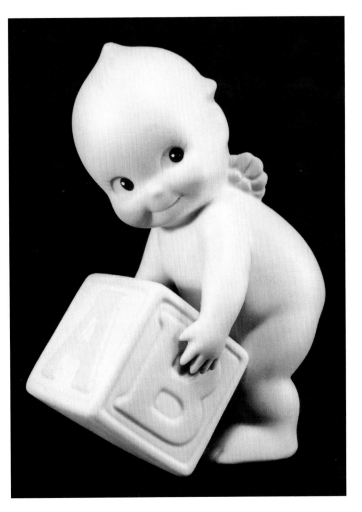

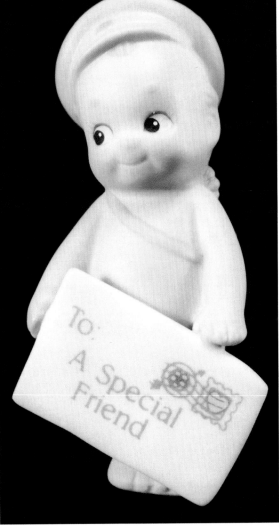

Statue, ceramic. Enesco Corporation/Jesco, 1993. Caption: "To a Special Friend." A Kewpie dressed as a mailman. 2.5" tall. $15-20.

Statue, resin. Enesco Corporation, 1993. Caption: "I Love You." A Kewpie holding a heart. This originally came in a pink heart shaped box. 1.75" tall. $10-15.

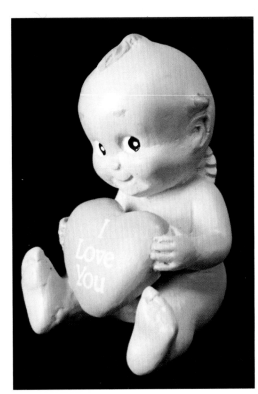

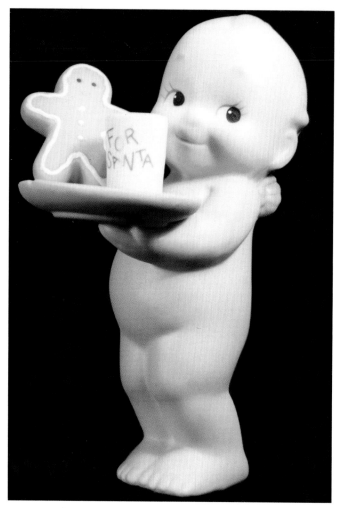

Statue, ceramic. Enesco Corporation/Jesco, 1993. Caption: "For Santa." A Kewpie holding a plate of milk and cookies. 4" tall. $20-35.

Pin, sterling silver. Manufacturer unknown, N/A. A 3-D Kewpie. 1.5" tall. $125-150.

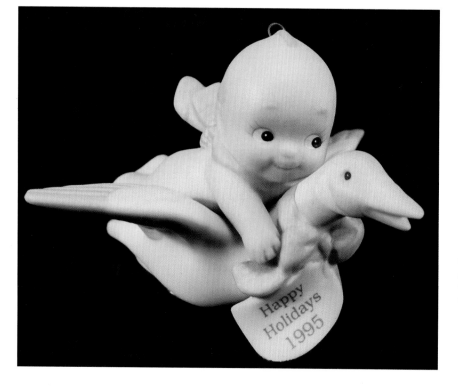

Ornament, ceramic. Enesco Corporation/ Jesco, 1995. Caption: "Kewpie Riding on a Goose." A Kewpie riding a goose. 2.25" tall. $20-35.

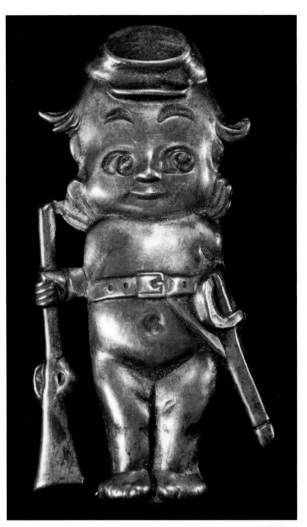

Pin, sterling silver. Truart, N/A. A Kewpie is dressed as a soldier. 2" tall. $85-100.

Stick pin, sterling silver. C.M.C., N/A. A Kewpie is dressed in a hat and scarf. 2.75" tall. $85-100.

Pin, pewter. Manufacturer unknown, N/A. A Kewpie with the letter K. 1.5" tall. $15-20.

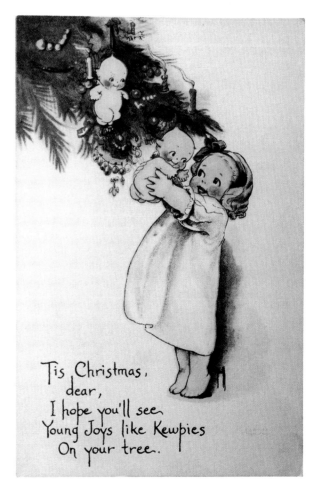

Postcard. The Gibson Art Company, N/A. Caption: "Tis Christmas, dear, I hope you'll see, young joys like Kewpies on your tree." One size. $20-35.

Pin, metal. Manufacturer unknown, N/A. Marked: Made in Czechoslovakia. A Kewpie look-alike in a red dress. 1" tall. $50-65.

Postcard. The Gibson Art Company, postmarked 1924. Caption: "Kewpie's playing Santa Claus, and comes to you to tell how, I hope this Merry Christmas finds you happy, gay and well." One size. $20-35.

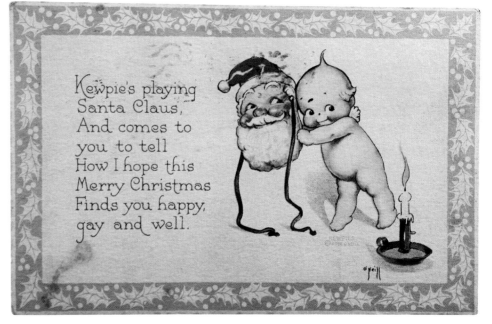

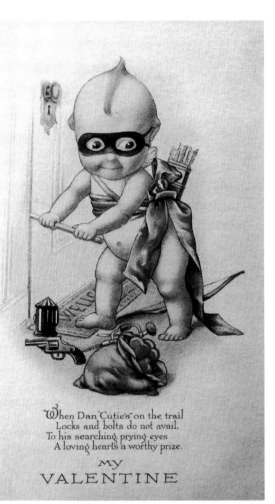

Postcard. Manufacturer unknown, N/A. Caption: "When Dan 'Cutie's' on the trail locks and bolts do not avail, to his searching prying eyes a loving heart's a worthy prize. My Valentine." One size. $20-35.

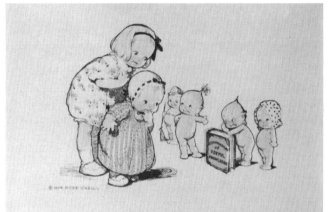

Invitation. Manufacturer unknown, 1914. Caption: "I am going to have a party …" 5.5" tall. $20-35.

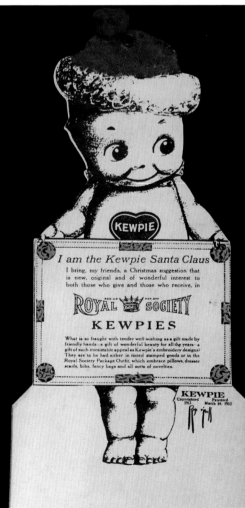

Advertisement. Manufacturer unknown, 1913. Caption: "I am the Kewpie Santa Claus. I bring, my friends, a Christmas suggestion that is new, original and of wonderful interest to both those who give and those who receive, in Royal Society. What is so fraught with tender well wishing as a gift made by friendly hands - a gift of wonderful beauty for all the years - a gift of such irresistible appeal as Kewpie's embroidery designs? …etc." 12" tall. $50-65.

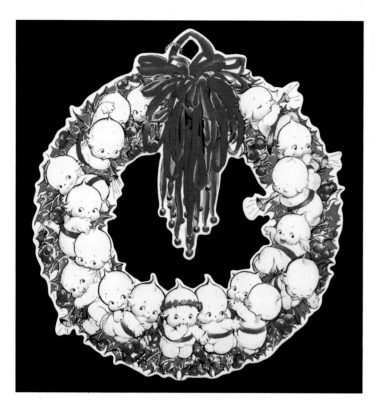

Decoration, cardboard. B. Shackman & Co., Inc., 1992. A wreath is surrounded by Pudgies [Kewpie look-alikes]. 6.5" tall. $10-15.

Stickers. B. Shackman & Co., Inc., 1988. Caption: "Set of 3 sheets die cut, pressure sensitive, and embossed Pudgie [Kewpie look-alikes] seals." One size. $5-10.

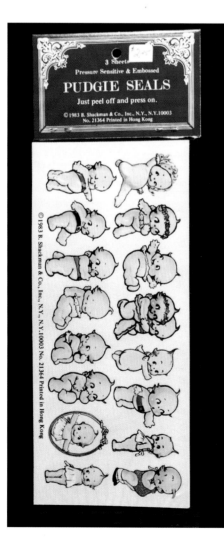

Stickers. B. Shackman & Co., Inc., 1983. Caption: "Set of 3 sheets die cut, pressure sensitive, and embossed Pudgie [Kewpie look-alikes] seals." One size. $5-10.

3-D Card. Merrimack Publishing Corp., 1984. Three Kewpie look-alikes in a rose garden. 7.5" tall. $15-20.

3-D Card. Merrimack Publishing Corp., 1984. Santa Claus is surrounded by Kewpie look-alikes. 7.25" tall. $15-20.

3-D Table centerpiece. American Greetings, 1973. Caption: "Kewpies! Valentine Centerpiece. This is an authentic Kewpie design. All Kewpies are the creation of Rose O'Neill (1874-1944), world renowned artist and writer who is best known as the 'mother of the immortal Kewpies.'" 10" tall. $20-35.

109

Lladró™

Statue, porcelain. Lladró, N/A. Caption: "Praying Angel, #4538, Open Issue, Currently Active." First issued in 1969. 5" tall. $100-125.

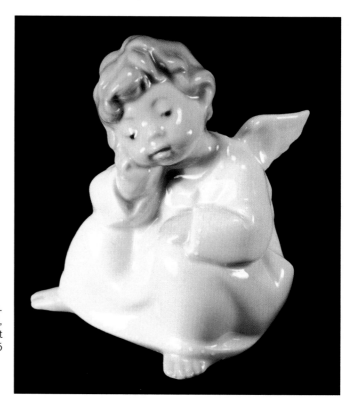

Statue, porcelain. Lladró, N/A. Caption: "Thinking Angel, #4539, Open Issue, Currently Active." First issued in 1969. 4" tall. $100-125

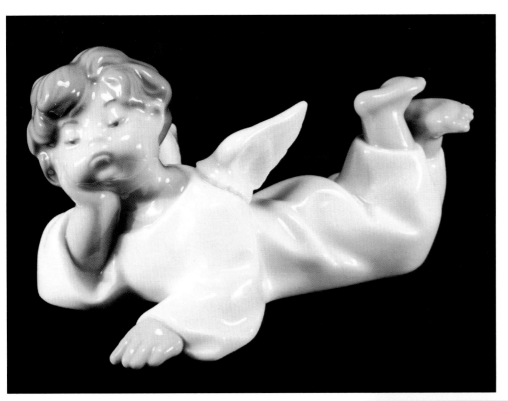

Statue, porcelain. Lladró, N/A. Caption: "Angel, Lying Down, #4541, Open Issue, Currently Active." First issued in 1969. 2.25" tall. $100-125

Statue, porcelain. Lladró, N/A. Caption: "Allegro Angelical, #6629, Open Issue, Currently Active" First issued in 1990. 5" tall. $150-175.

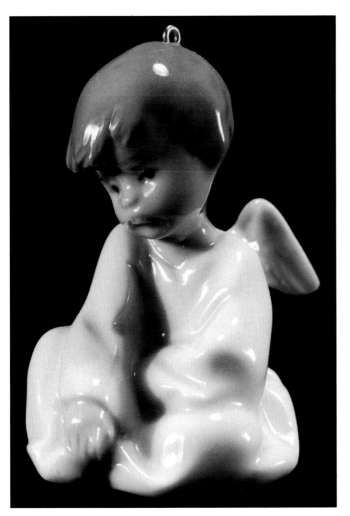

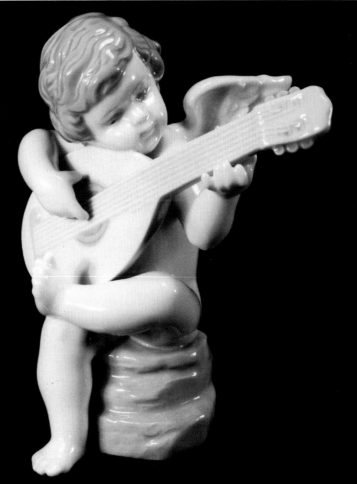

Ornament, porcelain. Lladró, 1988. Caption: "Angels, #1604, Christmas Ornaments, Limited and Open Editions." Only issued in 1988. First in set of three. Angel sitting. Under 2" tall. $150-175 set. *Courtesy of Sue Zak.*

Ornament, porcelain. Lladró, 1988. Caption: "Angels, #1604, Christmas Ornaments, Limited and Open Editions." Only issued in 1988. Second in set of three. Angel standing. Under 2" tall. *Courtesy of Sue Zak.*

Ornament, porcelain. Lladró, 1988. Caption: "Angels, #1604, Christmas Ornaments, Limited and Open Editions." Only issued in 1988. Third in set of three. Angel praying. Under 2" tall. *Courtesy of Sue Zak.*

Precious Moments™

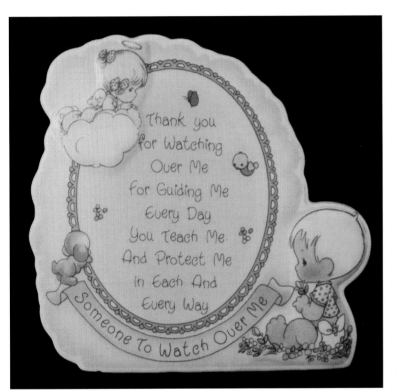

Plaque, bisque. Enesco Corporation, 1992. No marking on back. Caption: "Thank you for watching over me. For guiding me every day. You teach me and protect me in each and every way." 4" tall. $15-20.

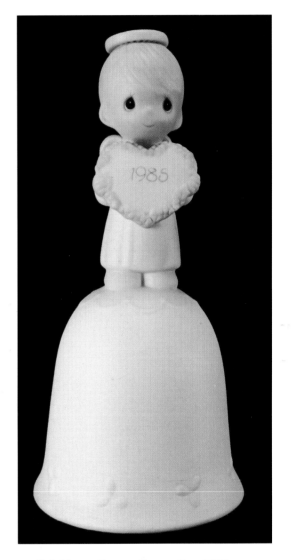

Bell, bisque. Enesco Corporation, 1985. Dove marking on base. Caption: "1985 Annual Edition Collectible Bell." An angel holding a heart. 5.75" tall. $30-45.

Statue, bisque. Enesco Corporation, 1979. Hourglass marking on base. Caption: "Charter Member. Enesco's Precious Moments Collector's Club. But Love Goes on Forever." Two angels are sitting on top of a cloud-shaped base. 5.25" tall. $150-175.

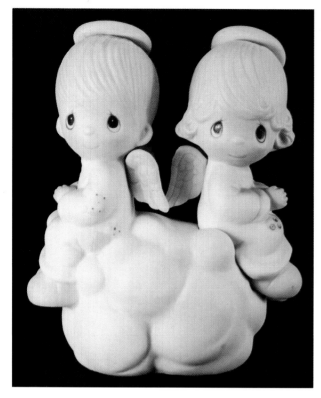

Statue, bisque. Enesco Corporation, 1979. No marking on base. Caption: "But Love Goes on Forever." Two angels are sitting on top of a cloud. 5.25" tall. $100-125.

Example of original box that the "Jesus is born" statue came in.

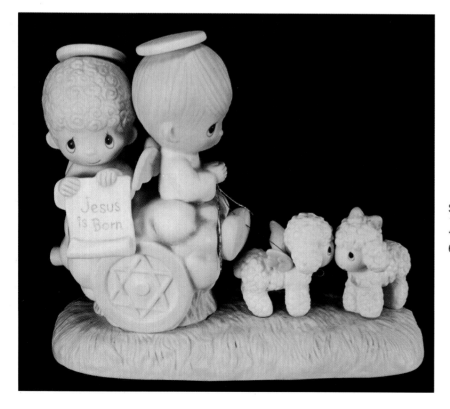

Statue, bisque. Enesco Corporation, 1979. No marking on base. Caption: "Jesus Is Born." Two angels in a cart. 6" tall. $375-400.

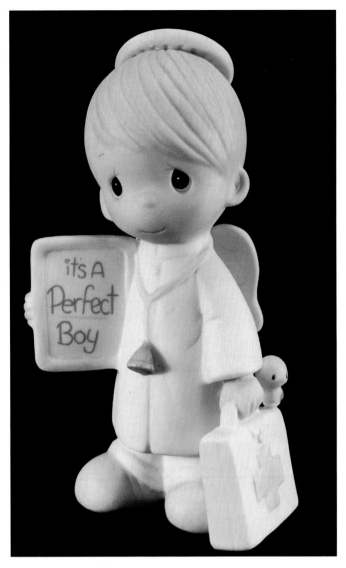

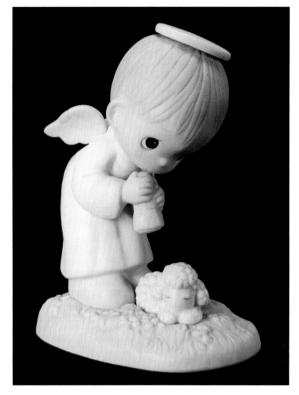

Statue, bisque. Enesco Corporation, 1984. Cross marking on base. Caption: "1984 Members Only Figurine. God's Ray of Mercy." An angel is holding a flashlight over a lamb. 4.75" tall. $50-65.

Statue, bisque. Enesco Corporation, 1983. Fish marking on base. Caption: "It's a Perfect Boy." An angel is dressed as a doctor. 4.75" tall. $60-75.

Statue, bisque. Enesco Corporation, 1985. Dove marking on base. Caption: "Halo, and Merry Christmas." Two angels making a snowman. 6.25" tall. $150-175.

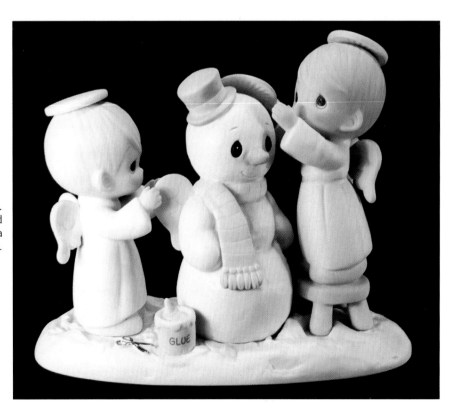

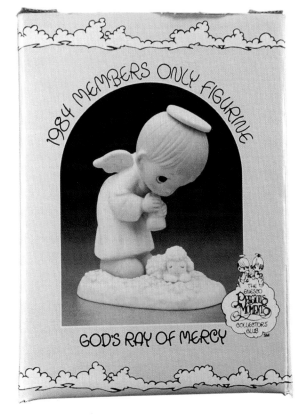

Example of original box that the "God's Ray of Mercy" statue came in.

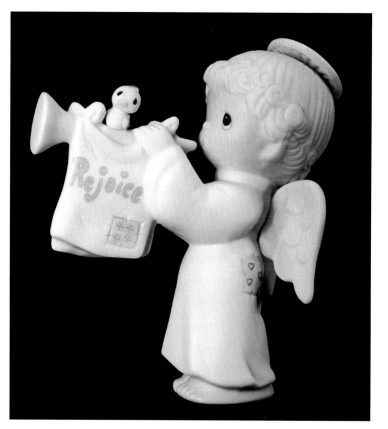

Statue, bisque. Enesco Corporation, 1980. Hourglass marking on base. Caption: "Rejoice O Earth." An angel playing a horn. 4.75" tall. $50-65.

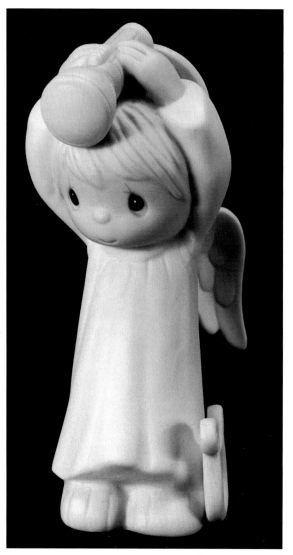

Statue, bisque. Enesco Corporation, 1980. Hourglass marking on base. Caption: "The Heavenly Light." An angel holding a flashlight. 4.75" tall. $50-65.

Ornament, bisque. Enesco Corpora-
tion, 1980. Hourglass marking on
base. Caption: "But Love Goes on
Forever." A boy angel is sitting on top
of a cloud. 3" tall. $100-125.

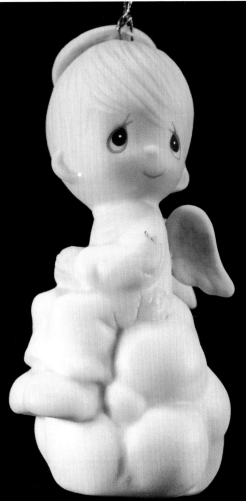

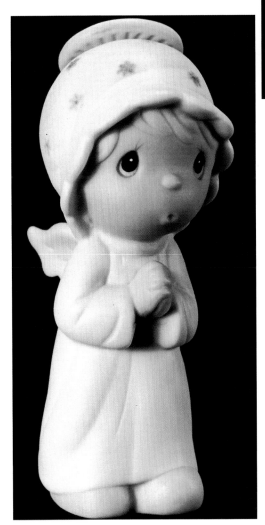

Ornament, bisque. Enesco
Corporation, 1980. Hourglass
marking on base. Caption: "But
Love Goes on Forever." A girl
angel is sitting on top of a cloud.
3" tall. $125-150.

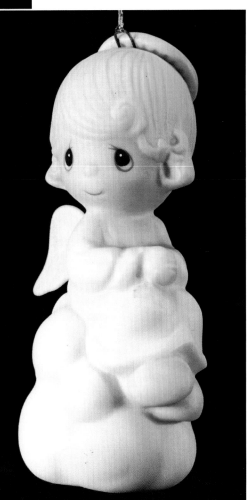

Ornament, bisque. Enesco Corpora-
tion, 1980. Hourglass marking on
base. Caption: "But Love Goes on
Forever." A boy angel is sitting on top
of a cloud. 3" tall. $100-125.

Statue, bisque. Enesco
Corporation, 1982. Hourglass
marking on base. Caption: "The
First Noel." An angel praying.
4.5" tall. $60-75.

Ornament, bisque. Enesco Corporation, 1982. Hourglass marking on base. Caption: "The First Noel." A boy angel holding a candle. 3" tall. $60-75.

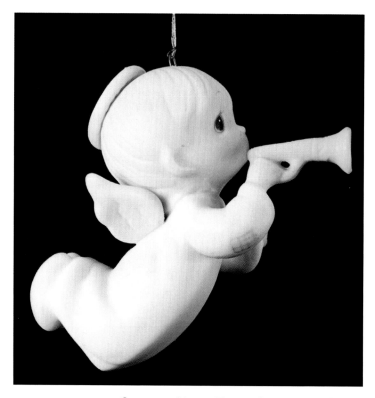

Ornament, bisque. Enesco Corporation, 1982. No marking on base. Caption: "Joy to the World." A boy angel blowing a horn. 2" tall. $20-35.

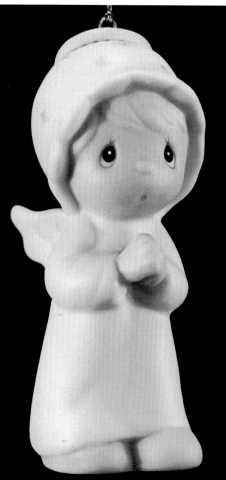

Ornament, bisque. Enesco Corporation, 1982. Cross marking on base. Caption: "The First Noel." A girl angel praying. 3" tall. $40-55.

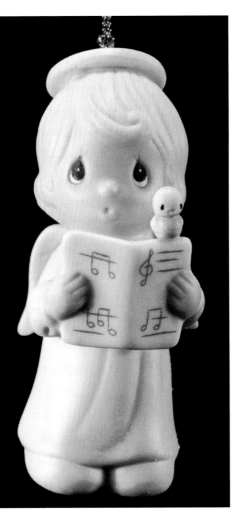

Ornament, bisque. Enesco Corporation, 1983. Fish marking on base. Caption: "Let Heaven and Nature Sing." A girl angel caroling. 3.25" tall. $50-65.

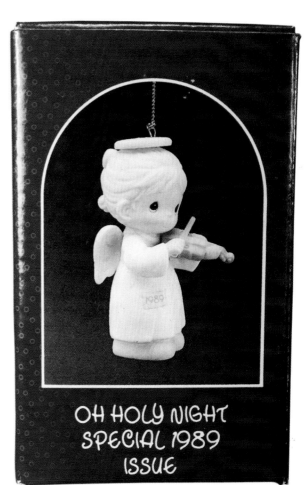

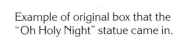

Example of original box that the "Oh Holy Night" statue came in.

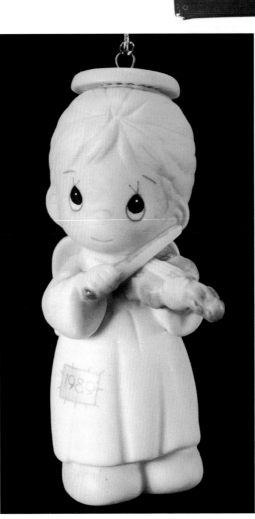

Ornament, bisque. Enesco Corporation, 1989. Bow and arrow marking on base. Caption: "Oh Holy Night Special 1989 Issue." A girl angel playing the violin. 3.25" tall. $20-35.

Snowbabies

Pin, metal/enamel. Department 56 Inc.,
N/A. 1.75" long. $10-15.

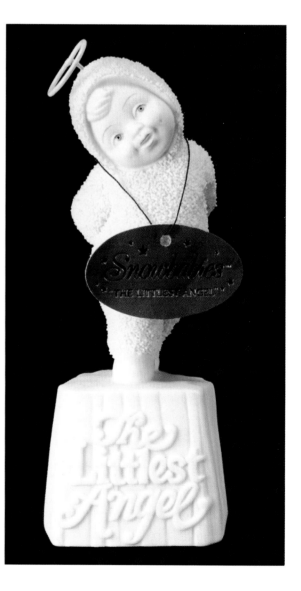

Statue, porcelain. Department 56 Inc.,
1999. Caption: "The Littlest Angel." A
snowbaby standing on a cube. 5.25"
tall. $20-35.

Statue, metal. Department 56 Inc., 1992. Caption: "You Didn't Forget Me." A snowbaby putting a star in a mailbox. 1.75" tall. $30-45.

Statue, metal. Department 56 Inc., 1996. Caption: "You Need Wings Too!" A snowbaby making a snowman. Two pieces in set. 1.75" tall. $15-20.

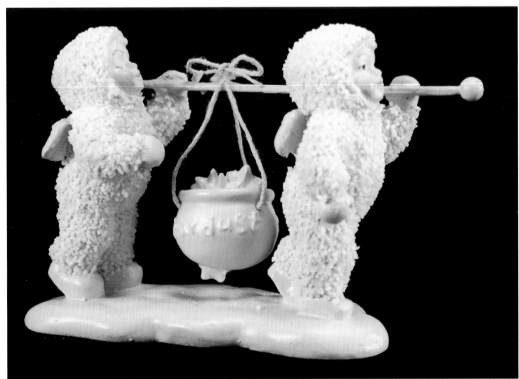

Statue, metal. Department 56 Inc., 1997. Caption: "Whistle While You Work." Two snowbabies carrying a pot full of stardust. 1.75" tall. $20-35.

Miscellaneous Christmas

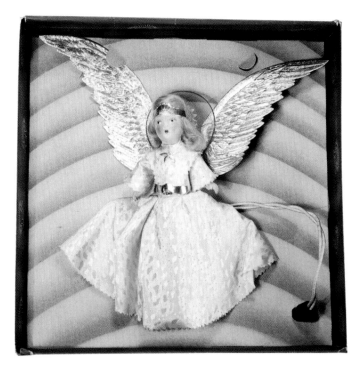

Tree top, composition/fabric. Noma Electric Corp., N/A. Caption: "Noma. Illuminated Tree-top. Halo Angel." 10.5" tall. $30-45.

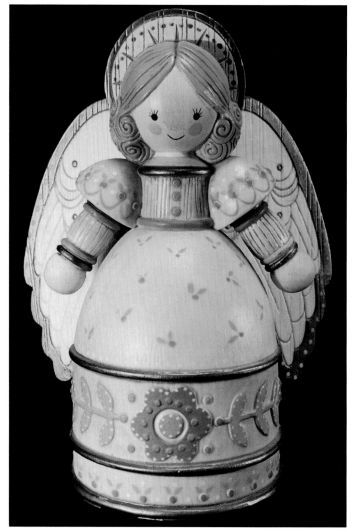

Tree top, plastic. Hallmark Cards, Inc., N/A. Caption: "Angel Tree Topper." 7" tall. $175-200.

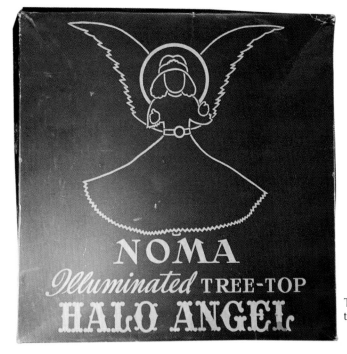

NOMA
Illuminated TREE-TOP
HALO ANGEL

The original box that the "Noma" tree top came in.

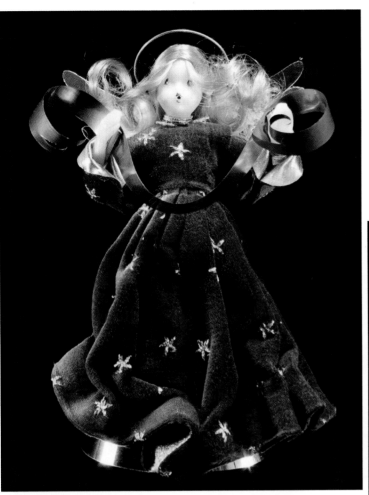

Tree top, wax/fabric. Pauline Leidel-Spreen, N/A. Marked: Made in Western Germany. 7.5" tall. $125-150.

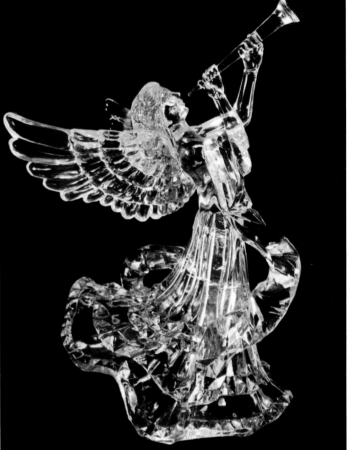

Tree top, plastic. Manufacturer unknown, N/A. An angel playing a horn. 10" tall. $10-15.

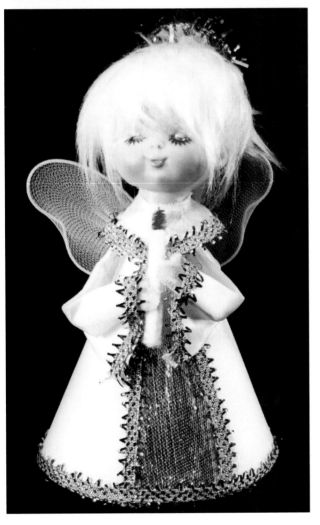

Tree top, vinyl/cardboard. Manufacturer unknown, N/A. Marked: Japan. An angel holding a pipe cleaner candle. 6.5" tall. $5-10.

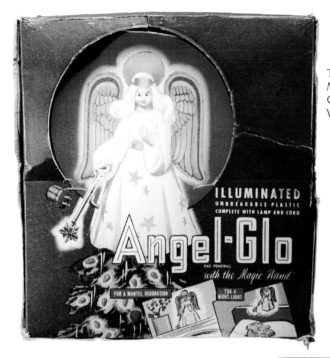

Tree top, plastic/material. The Glolite Corporation, N/A. Marked: USA. Caption: "Illuminated Unbreakable Plastic. Complete with lamp and cord. Angel-Glo with the Magic Wand." 7.5" tall. $20-35.

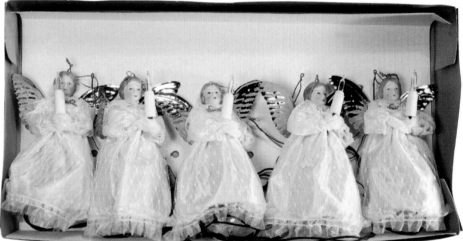

Lights, porcelain/material. Foremost Industries, N/A. Ten angels decorate the string of lights. One size. $20-35.

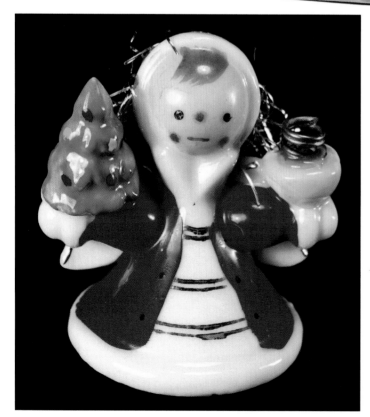

Candle holder, ceramic. Manufacturer unknown, N/A. Marked: Japan. An angel holding a Christmas tree. Complete with tinsel hair. 2" tall. $15-20.

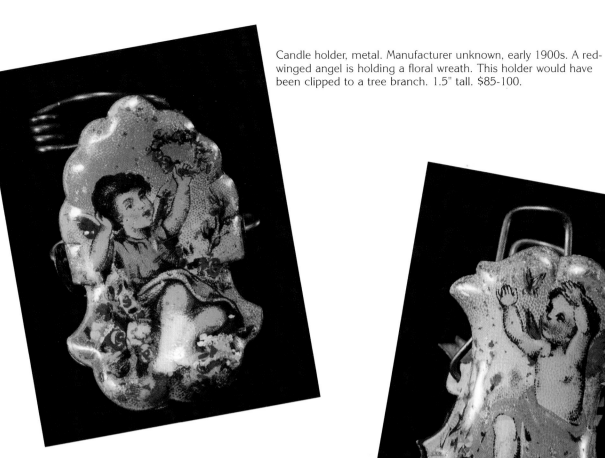

Candle holder, metal. Manufacturer unknown, early 1900s. A red-winged angel is holding a floral wreath. This holder would have been clipped to a tree branch. 1.5" tall. $85-100.

Candle holder, metal. Manufacturer unknown, early 1900s. A red-winged angel is playing with a yellow butterfly. This holder would have been clipped to a tree branch. 1.5" tall. $85-100.

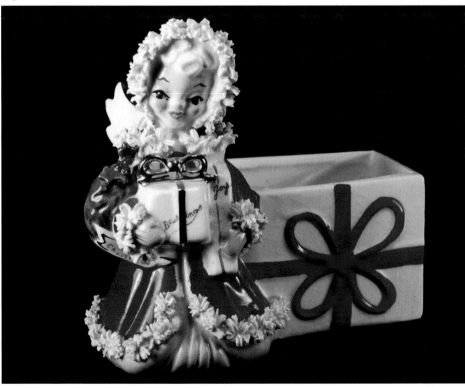

Planter, ceramic. Napco, N/A. Marked: Japan. An angel is holding gifts of joy and blessings. 5" tall. $15-20.

Pin, plastic. Hallmark Cards, Inc., N/A. A blue eyed angel holding a Christmas tree. 1.5" tall. $10-15.

Pin, metal. Hallmark Cards, Inc., N/A. An angel praying. 2.5" tall. $5-10.

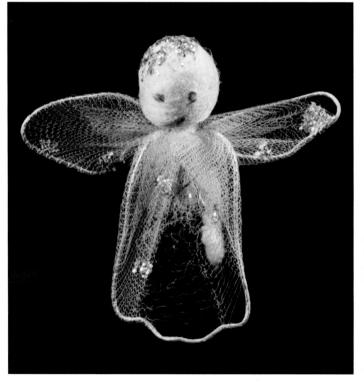

Gift decoration, cotton and netted material. Manufacturer unknown, N/A. There is a pipe cleaner on the angel's back that can be adhered to a package. 1.75" tall. $1-3.

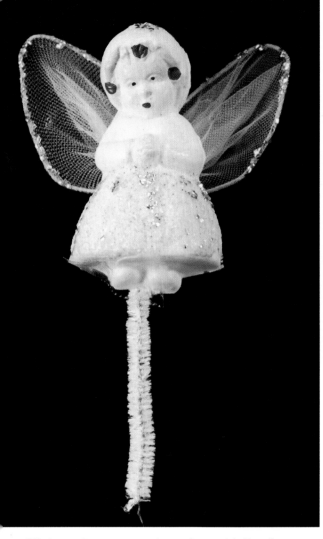

Stocking hanger, plastic. Hallmark Cards, Inc., 1983. Caption: "Angel Stocking Hanger." An angel holding a gold star. 3" tall. $50-65.

Gift decoration, cotton and netted material. Manufacturer unknown, N/A. There is a pipe cleaner on the angel's base that can be adhered to a package. 3.25" tall. $1-3.

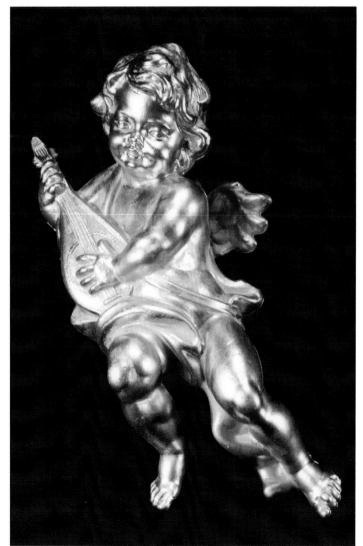

Decoration, plastic. Pacific Rim, N/A. A gold angel playing the lute. 11.5" tall. $10-15.

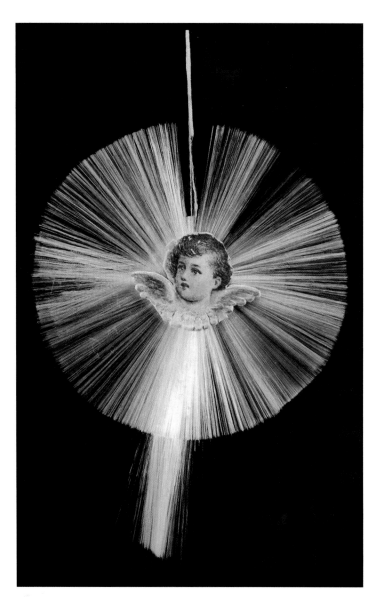

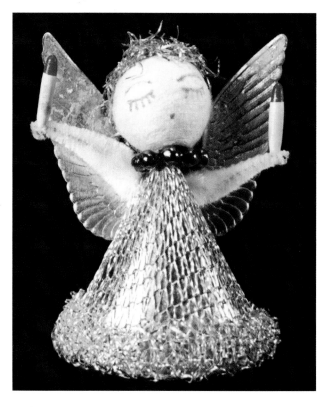

Ornament, cotton/fabric. Manufacturer unknown, N/A. Marked: Japan. A foil angel holding two candles. 2.5" tall. $3-5.

Ornament, spun glass/paper. Manufacturer unknown, early 1900s. A paper angel in the center of a circular star burst. 5.25" tall. $40-55.

Ornament, wax/fabric. Manufacturer unknown, early 1900s. A wax angel wearing a mesh skirt. 4" long. $150-175.

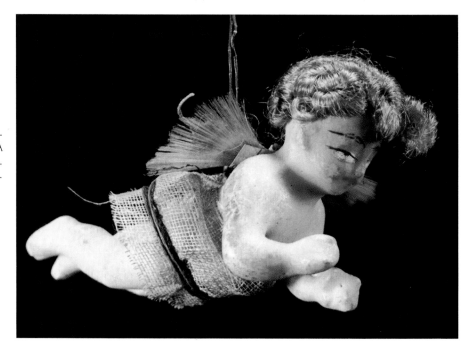

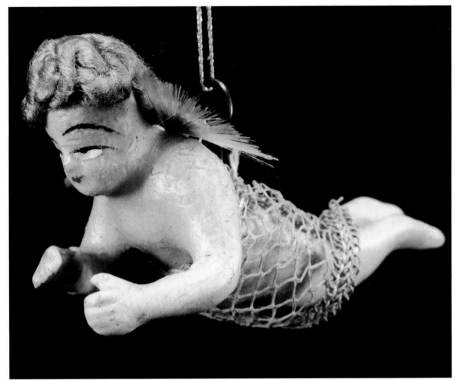

Ornament, wax/fabric. Manufacturer unknown, early 1900s. A wax angel wearing a mesh skirt. 4" long. $150-175.

Ornament, ceramic. Goebel, N/A. Marked: West Germany. An angel holding an accordion. 3.5" tall. $50-65.

Ornament, ceramic. Lenox, N/A. A white angel playing the violin. 5" tall. $20-35.

Ornament, ceramic. Lenox, N/A. Caption: "Come All Ye Faithful." 3.25" in diameter. $20-35.

Ornament, bone china. Royal Doulton, 1992. Caption: "The Joy of Christmas. From original artwork by Carol Lawson." An angel peeking through a wreath. 2.75" in diameter. $20-35.

Ornament, glass. Manufacturer unknown, N/A. A metallic pink angel playing the horn. 3" tall. $10-15.

Ornament, glass. Manufacturer unknown, N/A. A metallic angel in a white and blue gown. 2.75" tall. $10-15.

Ornament, porcelain. Midwest Importers, N/A. An angel wearing a pink hooded coat. 3.5" tall. $10-15.

Ornament, porcelain. Midwest Importers, N/A. An angel wearing a pink coat and blue hat. 3.5" tall. $10-15.

Ornament, porcelain. Hallmark Cards, Inc., 1984. Caption: "Classical Angel. Edition limited to 24,700 maximum." An angel holding two gold bells. Complete with wood display stand. 5" tall. $100-125.

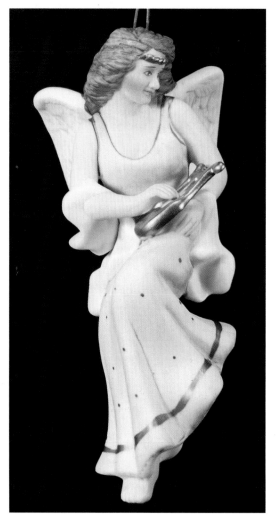

Ornament, porcelain. Hallmark Cards, Inc., 1988. Caption: "Angelic Minstrel. Edition limited to 49,000 maximum." An angel playing the lyre. Complete with wood display stand. 5" tall. $50-65.

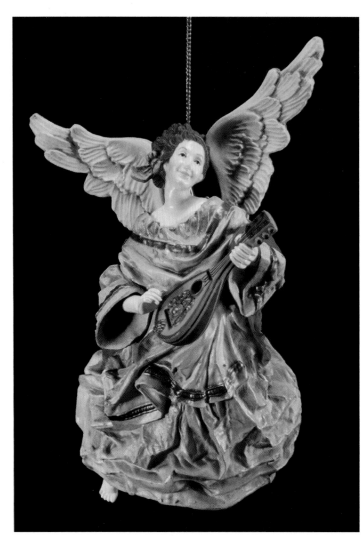

Ornament, plastic. Hallmark Cards, Inc., 1980. Caption: "Heavenly Minstrel." An angel playing a lute. 6.25" tall. $350-400.

Ornament, wood. Manufacturer unknown, 1986. An angel holding some holly. 5.75" tall. $10-15.

Ornament, wood. Manufacturer unknown, 1986. An angel holding some holly. 6.5" tall. $10-15.

Ornament, wood. Manufacturer unknown, N/A. An angel holding hearts and a star. 3.75" tall. $10-15.

Ornament, wood. V. Braun, 1971. A red-haired angel in a blue gown. 2.5" tall. *Private collection.*

Ornament, wood. V. Braun, 1971. An angel playing the cymbals. 2.5" tall. *Private collection.*

Ornament, wood. V. Braun, 1971. An angel playing the harp. 2.5" tall. *Private collection.*

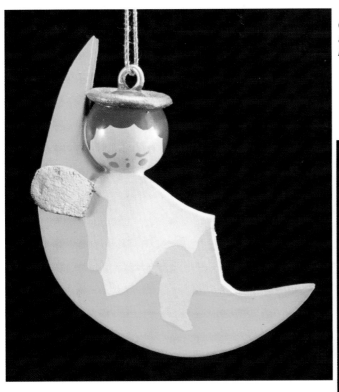

Ornament, wood. V. Braun, 1971. An angel sleeping on the moon. 3" tall. *Private collection.*

Ornament, bisque. Avon, 1983. An angel wearing a white gown with blue stripes. 1.75" tall. $10-15.

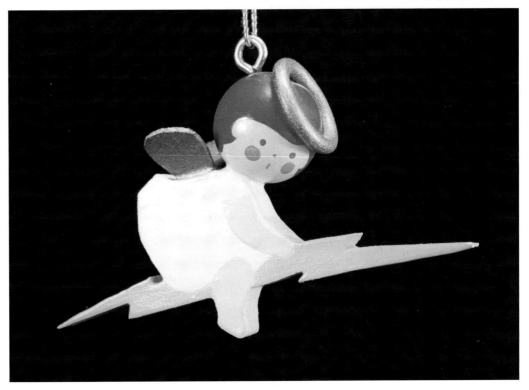

Ornament, wood. V. Braun, 1971. An angel riding on bolt of lightning. 2" tall. *Private collection.*

Ornament, ceramic. Morehead, Inc./Enesco
Corp., 1985. An angel holding a yellow bird.
2.5" tall. $10-15.

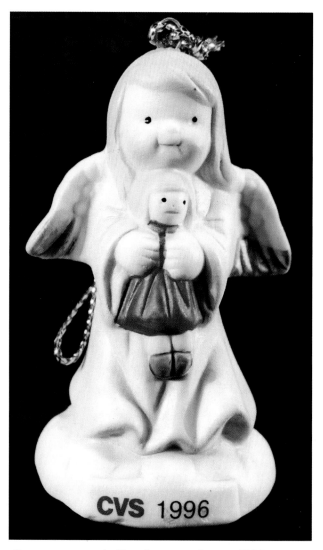

Ornament, ceramic. Manufacturer unknown, 1996.
Promotion for CVS Pharmacy. An angel holding a doll.
2.75" tall. $5-10.

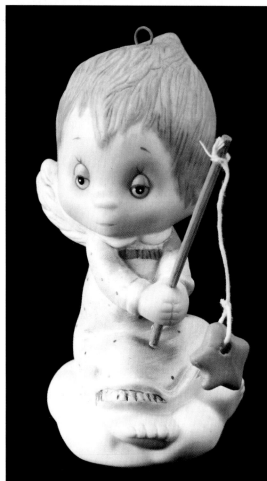

Ornament, porcelain. Hallmark Cards, Inc., 1983.
Caption: "Betsey Clark Keepsake Ornament." Betsey
Clark is fishing for stars. Hand-painted. 3" tall. $40-55.

Ornament, porcelain. Hallmark Cards, Inc., 1984. Caption: "Betsey Clark Keepsake Ornament." Betsey Clark is playing the mandolin. Hand-painted. 3.5" tall. $40-55.

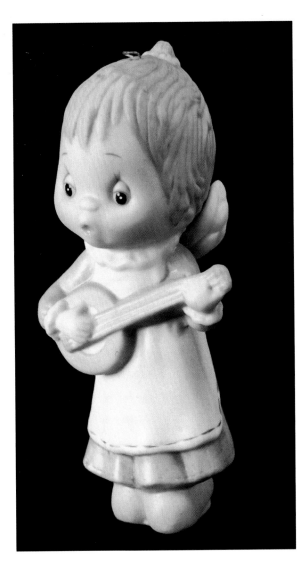

Ornament, ceramic. Manufacturer unknown, 1981. Designed by Joan Walsh Anglund. 3" tall. $30-45.

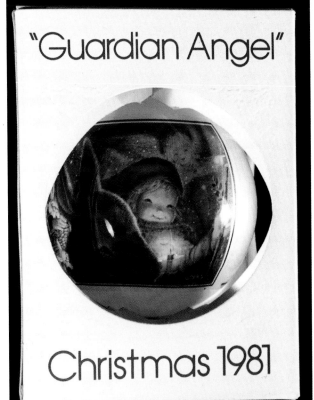

Ornament, satin. Schmid, 1981. Caption: "Guardian Angel © Ferr-Art by Ferrandiz. Christmas 1981 Fourth Limited edition." 3" in diameter. $15-20.

Ornament, plastic.
Manufacturer unknown,
N/A. Marked: Hong Kong.
An angel playing with
bunnies and birds. 2.75"
tall. $5-10.

Ornament, plastic. Art Plastic, N/A.
Marked: Hong Kong. An angel holding
a choir book. 3.5" tall. $5-10.

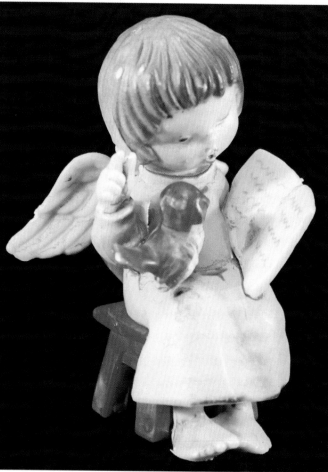

Ornament, plastic. Manufacturer
unknown, N/A. Marked: Hong Kong. An
angel reading to a bird. 2.25" tall. $5-10.

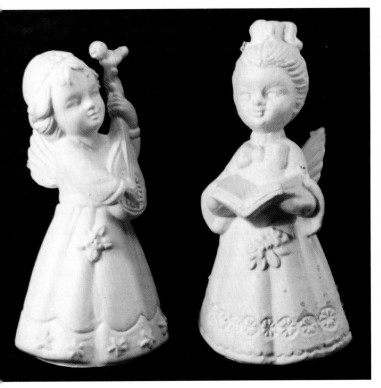

Ornaments, plastic. Manufacturer unknown, N/A. Two pink angels. 3" tall. $3-5 each.

Ornament, plastic. Manufacturer unknown, N/A. Marked: Made in Western Germany. An angel holding a lantern. 2.5" tall. $15-20.

Ornament, resin. Midwest of Cannon Falls, N/A. An angel playing a horn. 4" tall. $20-35.

Ornament, plastic. Hallmark Cards, Inc., 1983. Caption: "Baroque Angels Keepsake Ornament." Two angels wrapped in pink ribbon. 2.25" tall. $125-150.

Ornament, plastic. Hallmark Cards, Inc., 1991. Caption: "Heavenly Angels Keepsake Ornament." First in series. An angel on an ivory plaque. 3" tall. $30-45.

Ornament, plastic. Hallmark Cards, Inc., 1987. Caption: "Heavenly Harmony Keepsake Ornament." An angel ringing a bell. Musical. 3.5" tall. $30-45.

Ornament, plastic. Hallmark Cards, Inc., 1988. Caption: "Miniature Ornament. Sweet Dreams." An angel sleeping on the moon. 1.25" tall. $20-35.

Ornament, plastic. Hallmark Cards, Inc., 1980-1981. Caption: "Tree-Trimmer Collection. A Heavenly Night." An angel sleeping on the moon. 2.75" tall. $40-55.

Ornament, plastic. Hallmark Cards, Inc., 1976. A cookie angel holding a snowflake. 2.75" tall. $175-200.

Ornament, plastic. Hallmark Cards, Inc.,
1984. Caption: "Keepsake Ornament.
Musical Angel." An angel playing a horn. 1.5"
tall. $70-85.

Ornament, tin. Hallmark Cards, Inc.,
1997. Caption: "Daughter." Designed
by Katrina Bricker. An angel decorates
a stocking. 4.25" tall. $15-20.

Ornament, plastic. Hallmark Cards, Inc., 1988.
Caption: "Buttercup." First in Mary's Angels series,
designed by Mary Hamilton. An angel sitting on a see-
through cloud. 2" tall. $50-65. *Author's note:* "Blue-
bell," the second in the Mary's Angels series, is selling
between $100-125.